PRECIOUS LEGACY

treasures
from the
Jewish
Museum
in Prague

Edited by
Jana Vytrhlik

POWERHOUSE
PUBLISHING

Part of the Museum of Applied Arts and Sciences

First published 1998
Powerhouse Publishing, Sydney

Powerhouse Publishing
part of the Museum of Applied Arts and Sciences
PO Box K346 Haymarket NSW 1238 Australia
The Museum of Applied Arts and Sciences incorporates the
Powerhouse Museum and Sydney Observatory.

Project manager: Julie Donaldson, Powerhouse Museum
Editing: Bernadette Foley
Design concept: MaD House Design
Desktop publishing: Anne Slam, Powerhouse Museum
Printing: Inprint, Brisbane
Produced in Bembo on QuarkXpress (PC)

National Library of Australia
Cataloguing-in-Publication
Precious legacy: treasures from the
Jewish Museum in Prague

Bibliography.
ISBN 1 86317 075 8

1. Zidovske muzeum v Praze — Exhibitions. 2. Art,
Jewish — Czech Republic — Exhibitions. 3. Art,
Jewish — Czech Republic — Bohemia —
Exhibitions. 4. Art, Jewish — Czech Republic —
Moravia — Exhibitions. 5. Art, Jewish — Czech
Republic — Prague — Exhibitions. I. Vytrhlik, Jana,
1952–. II. Powerhouse Museum.

704.0392404370749441

Published in conjunction with the exhibition *Precious
legacy: treasures from the Jewish Museum in Prague*
at the Powerhouse Museum, Sydney
17 December 1998 – 28 February 1999

Major sponsors

Sponsors

 The Victor Smorgon
Charitable Fund

Supported by

at the Immigration Museum, Old Customs House,
Melbourne
25 March – 13 June 1999

Cover image: Torah crown, Prague, 1839. Repoussé,
cast, hammered, engraved and gilt silver, 54 x 37 cm.
A crown, the symbol of royalty and wisdom, decorates
the top of the Torah scroll. 19/82

Back cover image: Shiviti plaque, Moravia, 1879–1880
(see pages 58 & 59). 1797

Image page 4: Wrought-iron candelabrum from a
synagogue, Prague, about 1830. Nine-branched
candelabra (*hanukkiah*) are used during the
Hanukkah festival. 31/96

CONTENTS

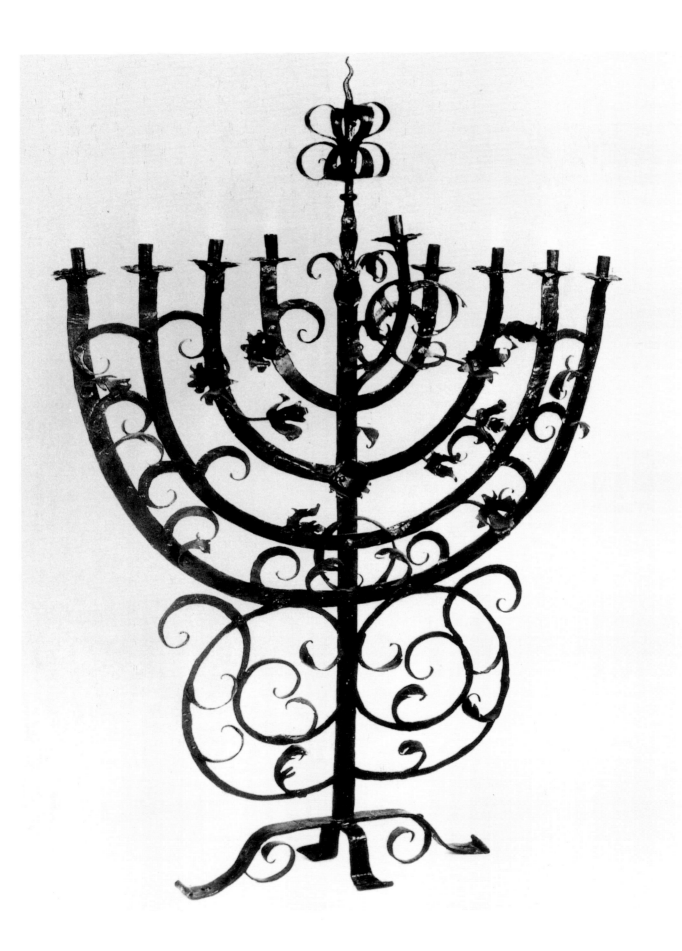

DIRECTORS' FOREWORDS

This publication has been produced in connection with the visit to Australia of a most important exhibition. *Precious legacy: treasures from the Jewish Museum in Prague* will allow Australians to see a selection of objects from a collection of the most profound significance. It represents and attests to the extraordinary story of the survival of Jewish legacy in Nazi occupied Bohemia and Moravia.

The history of the Czech Jewish community goes back over a thousand years but it was not until 1906 that Prague's Jewish Museum was founded to collect and record the Jewish heritage of the region. It must surely be one of history's most bitter ironies that this urge to document a great tradition was accelerated dramatically by the Nazi occupation. As my colleague Leo Pavlát tells in his foreword to this book, the development of the collection of Judaica was the agenda of the Jewish community facing extinction. That they persuaded their oppressors to authorise a comprehensive collecting and documenting strategy must be one of the most heroic stories of the century. Chief among the heroes were the museum's curators and historians who pitted their scholarly expertise against the lethal Nazi machine. Although few of them lived to see it, they achieved their mission, which was nothing less than the survival of their cultural heritage and the identity of their community.

Today, people wonder about the purpose of museums. Their purpose is still the same: the conservation and preservation of our cultural heritage and with that, the more certain definition our own identity as a society.

The Powerhouse Museum is many things. It collects in the field of decorative arts and is therefore pleased and privileged to stage *Precious legacy*, which is most certainly a great collection of decorative art and design. The Powerhouse is also a museum of social history, of the heritage of communities. In Australia, this is an important role as so many culturally diverse societies co-exist here and enrich one another. *Precious legacy* shows what a community can do in the most hostile context imaginable, to maintain the richness of its traditions for those who will inherit it.

I wish to record my thanks to Dr Jana Vytrhlik for her work as curator of *Precious legacy* in Australia and as principal author of this publication. Nobody could be better qualified for the task: she is Czech and worked as a curator on the staff of the Jewish Museum in Prague. Moreover, she did her doctoral thesis on its collection. In Sydney, over a period of ten years, she led all the Powerhouse Museum's programs in the area of cultural diversity — and people from many different cultures in Sydney's rich mix have come to know her and value her efforts. I also want to express my appreciation of the work of members of the Board of Trustees towards the exhibition and this publication. In particular, I mention Dr Gene Sherman for her valuable encouragement. Aside from the Trust, Gene and Brian Sherman are among many generous supporters in Sydney who have provided funds necessary to this program in a difficult economic climate.

I thank the many sponsors and other donors who are listed in the 'Acknowledgments', and also the museum's public whose visits are a tangible expression of support for the Powerhouse. There is much evidence that our public loves its Powerhouse Museum and that affection is as necessary for the museum's future as any other form of support, governmental or otherwise. If that sounds emotional, maybe it's appropriate as we show and write about *Precious legacy*. This is an exhibition and book for all cultural groups and for every member of our magnificent Australian community.

Terence Measham
Director, Powerhouse Museum, Sydney

The Jewish Museum in Prague has been exhibiting its unique objects around the world, but this exhibition is somehow exceptional. This is because it is the first time a representative selection of our collection will be seen 'Down Under'. I think the exhibition will also be exceptional thanks to the audience who will come to see it. Australia is well known for its cultural diversity and plurality, to which the Jewish community contributes a great deal. I have no doubt that the artefacts of the Jewish customs and traditions will be fully appreciated in this environment.

It is common knowledge that the Nazis ordered the dispatch to Prague of around 40 000 liturgical and other objects of great historical value which had been confiscated from the Jews. They gathered this immense collection, together with tens of thousands of Jewish books, in the Central Jewish Museum which they had established. The fate of these objects foreshadowed the fate that was to befall their original owners — first the objects were numbered, then the people. Unlike the objects, however, most of the Jews did not survive the war. Such a terrible linking of the fate of people and objects has sometimes been seen as an attempt by the Nazis to establish a museum that would commemorate the culture of an extinct race by housing the most valuable Jewish relics seized from occupied Europe. Although one cannot rule out that the Nazis had such an intention, there is no clear evidence for this. What is certain, however, is that the Prague Jewish Museum has never housed collections from other countries. Moreover, there is proof that the idea of bringing together confiscated objects in the Prague Jewish Museum (in existence since 1906) came from the Prague Jewish community and not from Nazi officials. The aim was to protect religious relics from destruction — even when the museum worked under Nazi supervision during the war.

After a partial restitution of objects to individuals and Jewish communities between 1945 and 1949, the museum was nationalised in 1950. It continued as the State Jewish Museum until September 1994 when it was returned to the Czech and Moravian Jewish communities.

While any discussion about the Jewish ceremonial objects was first silenced during World War II, this silence continued during the communist era: objects were presented as mere craft products without their spiritual dimension or historical connection. Today, the Jewish Museum is managed by the Jewish community and as such strives to emphasise the spirituality and historical context of the collection. This is helped by a program of reconstruction of Prague's synagogues where the exhibitions take place and which in themselves are admirable evidence of the richness of the Jewish legacy in Bohemia and Moravia.

To see the synagogues, one would have to travel to Prague. Objects, however, can be moved. This exhibition brings to Australia the precious Jewish legacy from Central Europe. Our selection offers a unique artistic and emotional experience. It gives an insight into the past which may remind some visitors of their own childhood and youth. At the same time, the exhibition is a testimony to the great Jewish culture and its magnificent contribution to humanity.

Leo Pavlát
Director, Jewish Museum in Prague

We are honoured that the first major travelling exhibition to be shown at the newly opened Immigration Museum in Melbourne, is *Precious legacy: treasures from the Jewish Museum in Prague*. The exhibition is a testament to the vitality of one of Europe's oldest Jewish communities. Through the exhibition and this publication the Immigration Museum is able to share with its audiences a powerful story, providing a deeper understanding of the cultural heritage, memory and experiences of a community.

The Judaica collection from Prague, the subject of this book, was first brought to my attention in 1997 by Dr Helen Light, Director of the Jewish Museum of Australia, in Melbourne. For many years Dr Light has sought to show this collection in Victoria. It is fitting that in conjunction with *Precious legacy*, the Jewish Museum of Australia in Melbourne is hosting a partner exhibition which explores the experiences of Czech Jews who settled in Victoria, providing an important local dimension.

Housed in the Old Customs House building, the Immigration Museum was established to explore the immigration experience of all non-indigenous people to Victoria. Through *Precious legacy* and this publication, the museum will move closer to achieving its vision of fostering understanding and tolerance, and celebrating the many dimensions of our cultural diversity.

Anna Malgorzewicz
Director, Immigration Museum, Melbourne

ACKNOWLEDGMENTS

When I worked in the State Jewish Museum in Prague in the late 1970s, the situation was very different from today. Who would have thought that two decades later, and 20 000 kilometres over the oceans, I would be reunited in Australia not only with the collection but with my former colleagues Eva Kosáková and Arno Parík, curators at the Jewish Museum in Prague?

My appreciation and admiration go to the team at the Smithsonian Institution in Washington, led by David Altshuler, Anna Cohen and Mark Talisman, which staged the first *Precious legacy* exhibition in North America in 1983. I will always be indebted to them for recognising the importance of the Judaica collection from Prague and making it accessible to the world outside the Iron Curtain.

The *Precious legacy: treasures from the Jewish Museum in Prague* exhibition and this publication were developed for the Australian public. I am grateful to the Powerhouse Museum management for this opportunity and would like to thank Terence Measham, Director, for his interest and support.

I wish to acknowledge the tremendous support I have received from the Sydney Jewish community. The staff of the Sydney Jewish Museum and members of the Jewish Arts and Culture Council, in particular, provided me with much needed encouragement and advice. Eva Scheinberg generously joined forces with me at the beginning of the project and assisted with the fundraising and later with the research and production of audiovisual testimonies. I appreciate the expert advice I have received from Rabbi Raymond Apple, AM, RFD, and Ivan Hybš.

The assistance and enthusiasm of Toner Stevenson, exhibition coordinator at the Powerhouse Museum was invaluable; she visited the Smithsonian Institution and brought back information about the *Precious legacy* exhibition when it was exhibited in the US and Canada. I have enjoyed exchanging ideas with all my colleagues who worked with me on the project and want to thank Roger Paris for his assistance on the exhibition. On the publication, it has been a pleasure to work with Suzanne Rutland, Julie Donaldson and Bernadette Foley.

Most of all I thank my mother who is still living in Prague. It was she who managed to smuggle my thesis from Czechoslovakia to Hungary after I escaped from the communist regime. The volume then travelled to Austria and New Zealand before it reached me in Sydney. It never entered my mind that I would one day be able to draw on it again.

The *Precious legacy* exhibition and this publication represent an enormous achievement in cooperation between the Powerhouse Museum and the Sydney Jewish community.

The following individuals, families and companies generously contributed financially to the exhibition:

Gold donors: Brian and Gene Sherman.

Silver donors: Ervin and Judith Katz; Alex Lowy; Albert Scheinberg; David and Eva Scheinberg; Richard and Jacqui Scheinberg.

Bronze donors: Michael Dunkel; Sotheby's Australia.

Donors: Eva and Paul Engel; Gerry Fischl; the Graf family; Andrew Korda; Barbara and Sam Linz; Medina Serviced Apartments; Ron and Judy Solomon.

Contributors: Eva Breuer Art Dealer Pty Ltd; John Landerer, CBE AM; Russia and Beyond tour operators; Dalia Stanley.

Other donors have also contributed but wish to remain anonymous.

The museum also wishes to acknowledge the support of the Consulate-General of the Czech Republic, Sydney.

Jana Vytrhlik

Jana Vytrhlik

A PRECIOUS LEGACY

Since the new Czech Republic opened its gates to the West in 1989, thousands of people have visited the Jewish Museum in Prague to discover the life of the community that has lived there since the early middle ages. Among the many collections of Judaica around the world, this museum is unique. It is located in the old Jewish ghetto, close to the remaining six synagogues, the Jewish town hall and the Jewish cemetery — historical sites that have witnessed the centuries of persecution and prosperity of Czech Jewish people.

The once large and vibrant community was decimated during World War II, leaving behind a legacy precious not only to those few who survived but to the entire world. Thousands of artefacts, rare manuscripts and early Hebrew printed books, richly embroidered synagogue textiles, ceremonial silver objects, glass and woodwork, oil paintings and examples of exceptional folk art which are held in the museum's collection testify to the richness of Jewish life in Central Europe. Today this collection is the most eloquent memorial to those who perished.

The narrow streets and gloomy houses of the Jewish ghetto in Prague are long gone. They were demolished at the beginning of the twentieth century to make way for new streets and buildings, and with them went three old synagogues. This prompted the historian Salomon Hugo Lieben and other Jewish scholars to preserve the ceremonial objects, furniture and manuscripts used in these synagogues. Soon they began to collect objects not only from Prague but from the provincial synagogues of Bohemia and Moravia as well. This focus on local material, which was maintained during and after the war, established the cohesion that is one of the most significant aspects of the collection. The objects have all been produced, brought to, or used by Czech or Moravian Jews.

The first public exhibition of the collection was held in 1909, and in 1912 the museum opened with a new permanent exhibition in the old ghetto. By 1938 large numbers of artefacts of historical value and 1500 rare Hebrew manuscripts and books were collected and catalogued, and many were put on display.

Soon after the Nazi occupation of Czechoslovakia in March 1939, the Jewish Museum in Prague entered a new phase. In line with the Nazi policy of the 'Final Solution to the Jewish Question', thousands of Czech Jews were deported to concentration and death camps. Facing this devastating situation, the museum's curators were determined to preserve the relics from the now deserted Jewish towns and villages. After prolonged negotiations, the Nazis issued an order in November 1941 that the 153 Jewish communities in Bohemia and Moravia had to send all their valuable ceremonial objects and other items of historical value to the newly renamed Central Jewish Museum in Prague. So, in an unprecedented and heroic action, the Jewish curators documented the world's largest collection of Judaica under direct Nazi order and supervision. By 1942 the deportations of Czech and Moravian Jews to the concentration camps increased dramatically and their belongings filled Prague's synagogues and countless warehouses.

The statistics of the war are revealing: in 1938 more than 118 000 Jews lived in Bohemia and Moravia; in 1945 over 80 000 were dead.[1] In 1938 the Jewish Museum housed a collection of some 2500 objects; by 1945 the collection had swelled to almost 150 000.[2]

After the war, the overflowing Jewish Museum had no resources left to care for the vast collection or for the synagogues and historic sites in the old Jewish ghetto. Consequently, following the communist takeover in 1948, the legacy of an entire Jewish population was offered as a gift to the Czechoslovak Government, and the next chapter in the museum's history began on 4 April 1950 with the establishment of the State Jewish Museum.

Prague's synagogues and places of worship were transformed into museum storage areas and exhibition halls, and to this day they house a collection that ranges from elaborate synagogue artefacts that testify to the former glory of the

Jewish community, to cherished family possessions used in the home. However, it quickly became obvious that the collection was a burden to the newly established regime. Rather than using the objects to tell the story of a rich culture spanning many centuries and pay homage to the victims of the Holocaust, the museum's bureaucrats enforced the path of lies, half-truths and silence. It was an unwritten museum policy that the use of the words 'Jew' and 'Jewish' was to be kept to an absolute minimum. Instead, terms such as 'war victim', 'victim of Nazi racial persecution', 'victim of fascism' or 'prisoners of concentration camps' had to be used. The term 'Holocaust' was largely unknown in the Czech Republic until the 1990s.[3] Concealed anti-Semitism and growing anti-Israeli policies intensified in the late 1970s. At this time some of the museum's staff were harassed and persecuted in relation to their involvement in the dissident civil rights movement, Charter 77.

Any meetings between a museum curator and a western scholar or museum professional, in particular those from the USA or Israel, had to be approved in advance and reported in detail afterwards. It was well known that the museum's phones were tapped as this practice was widespread for several decades.

While international tourists still visited the State Jewish Museum, they could see all but learn very little as the museum buildings were really only storage facilities for the collection. Until the 1980s, the exhibitions and the storage stacks all looked the same. Museum management regarded any attempt by curators to explain the origin, purpose or symbolism of the objects as inappropriate and visitors were not told of the tragic destiny of the objects' owners. This important cultural resource was degraded to a mass display of craft production and the existence of the Jewish population was denied.

Under the communist regime the Jews of Bohemia and Moravia became an erased race.

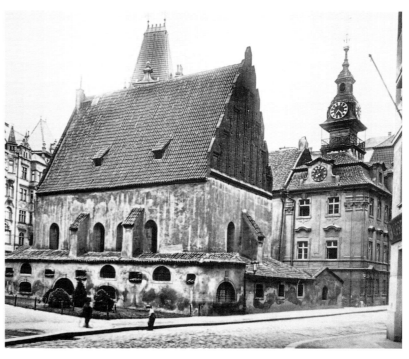

Two generations of Czech people grew up untouched and ignorant of the Jewish culture. Edith Sheldon (nee Drucker), a Holocaust survivor who was born in Prague and now lives in Sydney, said that the communists 'pretended that all the people who died were anti-fascist. Theresienstadt was presented as an anti-fascist prison, not a Jewish ghetto. It was not stressed that the Jews were the main recipients of all the terror'.[4] One of the curators of the State Jewish Museum summed up the situation by saying, 'In Prague, you could learn more about the Indians of South America than about the Czech Jews'. Apart from a brief flourishing during the Prague spring in 1968, the museum did not organise any lectures or other education activities. For decades staff of the State Jewish Museum faced endless difficulties as they carried out their work.

Soon after the collapse of the communist regime in Czechoslovakia in 1989, however, there was a tangible change in attitude toward Jewish culture. Second and third generation Jewish children were now eager to discover their

Jewish Town, Prague, in 1915. The gothic Altneuschul (Old–New Synagogue) from the 13th century (centre) **and Jewish Town Hall** (right) **were saved during the ghetto clearance at the turn of the century. Today, this is the oldest synagogue in Central Europe.**
Photo courtesy Jewish Museum in Prague

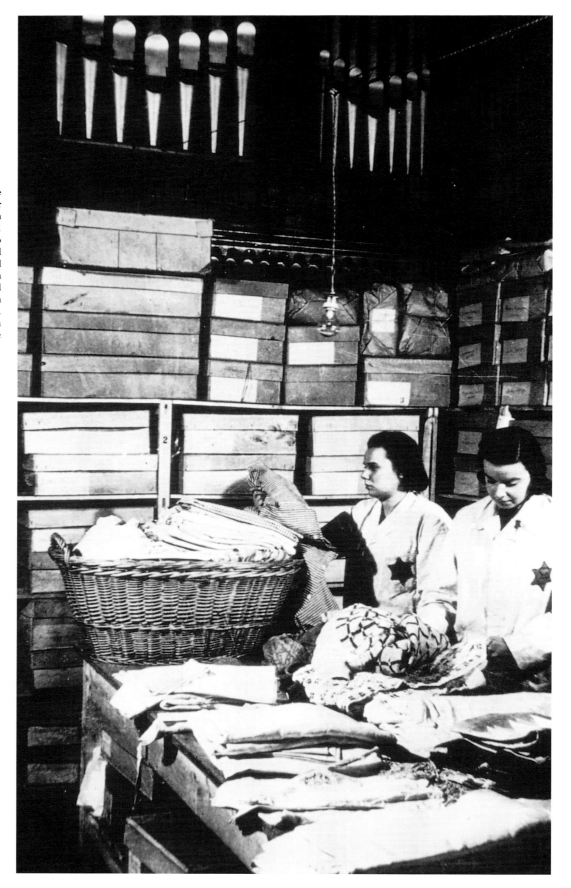

Facing the possible destruction of their precious legacy, Jewish curators in 1941 convinced the Nazis to collect confiscated artefacts of historical value and house them in the newly renamed Central Jewish Museum in Prague.
Photo courtesy Jewish Museum in Prague

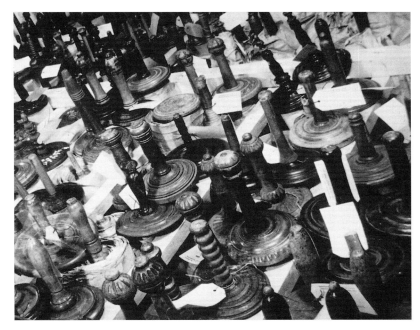

heritage, and their starting points were the old ghetto and the museum in Prague. In 1994 the State Jewish Museum was returned to the administration of the Federation of Czech Jewish Communities under a new name, the Jewish Museum in Prague. Dr Leo Pavlát was nominated as director and immediately began restoration, exhibition and education programs.

The Jewish Museum in Prague is an important centre for research into Jewish arts and crafts, particularly textiles and silver. Also, with thousands of documents, historical photographs and archival material, the collection is a valuable resource for the study of technology, industry and socio-demographic changes and development in Central Europe from the sixteenth to the twentieth century.

The collection spans seven centuries: from the oldest preserved Hebrew manuscript made in the thirteenth century to silver and textile ceremonial artefacts from the sixteenth century; a group of fine paintings from the eighteenth century to the 1960s; and ceremonial objects from the eighteenth century up to the 1930s.

Although Jews have lived in Bohemia and Moravia since the tenth century, their regular persecution and expulsion throughout history, the many prohibitions forced upon them, and the destruction of their synagogues prevented any large-scale preservation of their material culture. With a few early exceptions, therefore, the development of Jewish arts and crafts can first be followed from the late sixteenth century. While artefacts were created for uses specific to the Jewish culture and religion, their production and style corresponded to the dominant artistic style of the period, such as baroque or empire. In small communities in Bohemia and Moravia, however, craft objects produced in the home often took their inspiration from the local folk art and traditions.[5]

A significant part of the collection of the State Jewish Museum were the confiscated Torah scrolls that were stored in a synagogue on the outskirts of Prague from the end of World War II. The scrolls lay unused and deteriorating as neither the museum nor the government had the resources or the expertise needed to conserve and store them properly. Through a mix of good fortune and perhaps also as a result of a gradual liberation that was in the air since the early 1960s, a Czechoslovak export agency began negotiations with the Westminster Synagogue in London. Finally, over 1500 scrolls arrived in London where they were lovingly restored and sent to synagogues around the world on permanent loan under the auspices of the Trustees of the Czech Memorial Scrolls of the Westminster Synagogue.[6]

From the fifteenth century, textile manufacturing in Bohemia developed rapidly, resulting in the production of exceptional pieces during the renaissance. Dating from this time is one of the oldest preserved Torah curtains in the world, donated by the Perslsticker family to a Prague synagogue in 1592 and now held in the museum's collection.

The combination of a flourishing textile industry and a vibrant Jewish community in Bohemia and Moravia contributed to the production of synagogue textiles on an unusually large scale and of exceptionally high quality. The textile collection in the Jewish Museum in Prague contains some 10 000 pieces, comprising mainly textiles used in synagogues, such as Torah curtains, mantles, valances, covers and binders. Numerous other pieces were made for domestic use, for example, embroidered *hallah* and *matzah* covers, *tefillin* bags and prayer shawls.

The Torah, the central point of Jewish life and faith. Here, Torah scrolls confiscated by the Nazis from nearly 200 Bohemian and Moravian synagogues are stored in the Central Jewish Museum in 1943.
Photo courtesy Jewish Museum in Prague

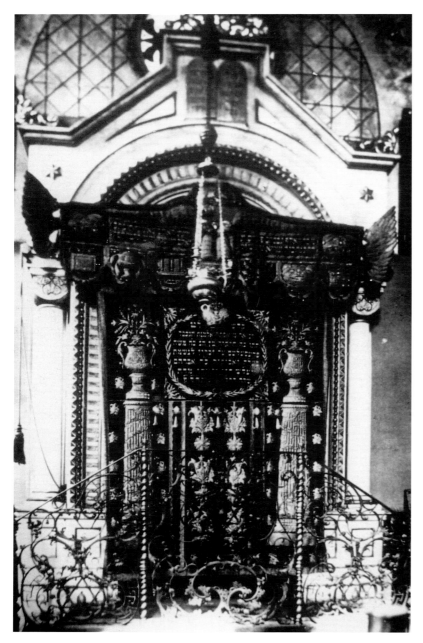

Pinkas Synagogue, Prague, built in the late 15th century, photographed in about 1900. *Aron ha-Kodesh* **(Holy Ark) decorated with a curtain, valance and eternal light.**
Photo courtesy Jewish Museum in Prague

Many of the oldest textiles in the collection were produced in Prague's workshop, including a Torah curtain, dated 1685–1686, which is made of silk velvet and richly embroidered with metallic threads, sequins and metallic ribbon *(illus p 35)*. Often women worked on intricate embroidery like this, assisted by men when the thick metal thread was too heavy for them to handle. Comparing pieces such as this curtain with textiles produced for the Catholic church at the same time suggests that there was an artistic interchange between non-Jewish and Jewish craftworkers.

The early examples of Torah mantles were elaborate and made from velvet and silk. From the beginning of the nineteenth century, however, they became more simplified. The later mantles were no longer produced in the workshops of skilled embroiderers, but were created in the households of devoted Jews. Some struggled to embroider even a simple Hebrew inscription, yet the love and dedication of the makers cannot be measured by the appearance of the finished pieces but by the hours spent making them. A piece donated to the local Bohemian synagogue, for instance, would have been made with the same sincerity and devotion as a silk embroidered mantle made in Prague.

In a synagogue, next to the textile decoration of the Torah, stand the silver ceremonial objects — Torah crowns, finials, shields and pointers. The oldest preserved silver objects in the Jewish Museum in Prague are crowns and finials dating from the seventeenth century. One shield held in the collection was made in Vienna in 1813 and dedicated to the Old Synagogue in Brno, Moravia, in 1830. Unlike the earlier, more elaborate examples with floral decoration, this shield has a stylised form with the two columns ending in a pair of hands raised in blessing. The crown adorning the top of the shield rests on leaves which sprout from the tablets of the Ten Commandments. Another shield was made in 1816 by Thomas Höpfel, one of the best-known silversmiths in Prague during the early nineteenth century. It is decorated with the imperial crown adorned with ribbons, which is commonly seen in Bohemian heraldry *(illus p 50)*.[7]

The collection in the Jewish Museum in Prague contains many objects that belonged to the inventory of the synagogue and Jewish households. These include *menorahs, Hanukkah* lamps, alms boxes, tankards and cups, spice boxes, ceremonial beakers and wedding plates, *mezuzot,* circumcision implements, wedding rings, and kitchen tools. One beautifully decorated, dark blue synagogue clock was used by a small Jewish community in Písek, Bohemia, to tell the time for prayers and services since the 1870s *(illus p 57)*. Looking at it one can almost imagine the

rush on a Friday evening to make it to the synagogue in time for service to welcome in the Sabbath.

A very special part of the collection comes from the war-period Theresienstadt concentration camp and includes works of art, documents and children's drawings and poems which have been exhibited worldwide.[8] In spite of the unimaginable living conditions, or rather because of them, adults — former teachers and artists — wanted to continue the children's education and secretly maintained a rich cultural life in the ghetto. During their drawing lessons the children were given a theme and were free to express it in their own way, often showing that they could see beauty and poetry where the adults saw suffering and pain. They drew scenes from their homes as they remembered them, pictures of animals and flowers, fairytale characters, landscapes they dreamed of, and family members and friends who were no longer with them.

Whether they are rare and exceptional artefacts, or just simple pieces of everyday Jewish life, the entire Prague collection of Judaica is a memorial to those who died and those who could not be born.

Notes

1. N Bergerová (ed), *Na krizovatce kultur*, Mladá Fronta, Prague, 1992.

2. Figures vary according to the criterion, in total over 150 000 items were registered. Out of this, some 40 000 were of artistic or historical value. Printed material, including manuscripts and books, amounted to 100 000 objects.

3. In 1975 when Jana Vytrhlik selected as the topic for her doctoral thesis a particular group of objects from the Judaica collection of the Prague museum, she was advised against it by university officials. Only when she adapted the focus of her study and the proposed title did not contain the word 'Jewish', was her proposal accepted. The title 'On problematic of the influence of the Moravian folk art on synagogue relics from Boskovice' replaced the intended thesis on 'Jewish community of Boskovice as reflected in the collection of the State Jewish Museum in Prague'.

4. Edith Sheldon interviewed by Eva Scheinberg and Katja Grynberg in Sydney on 6 July 1998 for the purpose of a testimony for inclusion in the *Precious legacy* exhibition.

5. J Vytrhlik, 'On problematic of the influence of the Moravian folk art on synagogue relics from Boskovice', doctoral thesis, Palacký University, Olomouc, Czechoslovakia, 1976.

6. There are some fifteen Czech Torah scrolls on permanent loan in Australia, including Sydney's Maroubra synagogue and Balmain congregation.

7. D Altshuler (ed). *The precious legacy: Judaic treasures from the Czechoslovak State Collections*, Summit Books, New York, 1983.

8. Theresienstadt, Czech Terezín, was a fortress town built in the 1780s, 60 kms north of Prague. In 1941 the Nazis transformed the town into a 'model' concentration camp. Some 140 000 Jews from around Europe, but mostly from Bohemia and Moravia, passed through the camp on their way to death camps. Amongst them were 15 000 children aged up to eighteen years old. Only 100 of them survived.

The old Jewish cemetery in Prague (1439–1787) mirrors the centuries of prosperity and oppression of the Jewish community. The ceremonial hall of the burial society *(back)* was used by the Jewish Museum in its early years.
Photo courtesy Jewish Museum in Prague

Jana Vytrhlik

A HISTORY OF THE JEWISH PEOPLE IN BOHEMIA AND MORAVIA

Surrounded by Germany on the west, Poland on the north, Slovakia on the east and Austria on the south, no other part of Europe better fits the description 'Heart of Europe' than the new post-communist Czech Republic, formed in 1993. It comprises Bohemia and Moravia, two neighbouring regions in Central Europe, whose people — the Czechs — their language and history are closely intertwined.

The region was inhabited from the fourth century BCE by Celtic tribes, the Boii, who gave Bohemia its name. The Slavic settlement dates from between the fifth and seventh centuries CE. Christianity was introduced to the region in the ninth century. While historical documents show that the Jewish population of Bohemia can be traced back to the tenth century, the earliest record of Jews in Moravia was documented in the late twelfth century.

Situated on the Vltava River, Prague, the capital of the Czech Republic, has a rich history and culture. Called the 'Jerusalem of the West', Prague has been a religious, cultural, intellectual and economic centre for European Jews for many centuries. Jewish merchants were first recorded working there in 965. Compared with other medieval towns in Central Europe, Prague and its rulers welcomed Jews and treated them more kindly, attracting caravans of Jewish merchants, renowned scholars and skilled trades people from both the East and the West.

Prague's medieval Jewish community was allowed to move freely, and Jewish people settled around the area where the Altneuschul (Old–New Synagogue) is situated today. They opened their first school and began to build the Jewish Town in the early eleventh century. Nevertheless, Jews were always regarded as foreigners due to their different appearance, way of life, language, religion and customs. Consequently, they tended to form tightly knit communities. When threatened by an outside danger, the Jewish people found it easier to seek protection and comfort behind the walls of their own quarters.

With the growing importance and expansive power of the Christian Church, various prohibitions and restrictions were enforced on the Jews. The Christian authorities began to fear that if contact between Christians and Jews remained unlimited, the sacred foundation of Christianity would be undermined. During the Crusades in the eleventh century, Jews in Prague became the victims of pogroms and forced baptisms, and mass emigration to neighbouring Poland began. A chronicle from 1098 reports that when the ruling prince learned that Jews were taking money and wealth with them, he ordered that all their property be seized: 'They left them nothing but a grain of corn …'[1] This situation was experienced in other Bohemian towns as well.

Hatred and envy of the Jews led to the most absurd accusations. One of the first references to the Jewish community in Moravia was in 1163 when it was reported that 27 Jews were executed in the town of Opava for allegedly poisoning the local well.[2] Yet the conditions in Bohemia and Moravia were more bearable than those in many other parts of Europe. The sovereigns did not oppose the Jewish settlement, and from time to time they issued charters which protected the Jews against the hatred of the Christian people. Why? Because they needed the growing Jewish wealth and business skills.

In 1215 the decree of the Lateran Christian Council, endorsed by the Pope, deprived the Jews of equality as citizens. They were proclaimed 'prisoners and slaves of the Roman Empire' and from then on they could not buy land or build houses, and social interaction with their Christian neighbours was limited. Perhaps the worst aspect of the decree was the order that Jews had to live in closed quarters, known from the sixteenth century onwards as ghettos. So that Jewish people could be distinguished when they were outside the ghetto, they had to be visibly marked. Jewish men in Bohemia had to wear large hats or a badge, and Jewish women had to adopt a special hairstyle. Centuries later the Nazis enforced a similar order.

From that time on the Jews were not allowed to stand for public office, produce goods outside

the ghetto, own rural properties or farm the land. One of the very few options open to them was to enter the field of finance, which was prohibited to Christians as money lending was considered to be a mortal sin. As a consequence of this belief the more successful the Jewish financiers were, the more they were hated. Although the Czech king took the Jews under his protection in 1254, his decree could not prevent later pogroms and persecution.

The most celebrated king of Bohemia was the Luxembourg, Charles IV. When he was crowned Holy Roman Emperor in 1355, Prague became the centre of the Holy Roman Empire, attracting architects, scholars, painters and sculptors from all over Europe. The kingdom reached a high level of prosperity and Charles is remembered for founding the University of Prague in 1348 and for commissioning many grand projects including the Charles Bridge and St Wenceslaw Cathedral.

Up to the end of the fifteenth century the number of Jews living in Bohemia and Moravia was not significant but, nevertheless, they were regarded as competition to the developing Christian businesses. That led to further expulsions of Jews from cities, towns and even villages. Old Jewish settlements were abandoned and new ones established. This devastation and disruption meant that objects from synagogues and homes from earlier times were not preserved.

In Bohemia the major Jewish centres were Prague and Kolín, with the rest of the Bohemian Jewish population living in many smaller settlements. All the Jewish people in Bohemia were under the direct administration of the king. In Moravia, however, there were no main Jewish centres and Jews were protected by the ruling class but had to pay a high ransom in return.

In about 1580, the Austrian Hapsburg Emperor Rudolf II moved his residence from Vienna to Prague, and the artistic, cultural and intellectual life of Prague developed even further. The Jewish community played an important role in

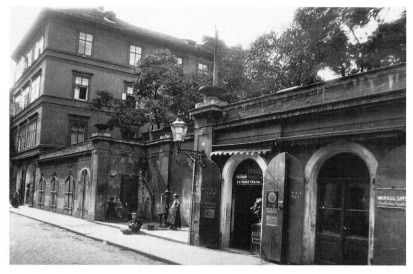

this cultural life. As Christians were still forbidden to lend money on interest, Jewish sources of finance were sought after.

One of the most famous and wealthiest Jews in Prague was Mordechai Maizl, Rudolf's first Jewish banker. Rudolf's wealth was spent maintaining his flourishing court and protecting the eastern borders of his empire against the Turks. Consequently, Mordechai Maizl became indispensable to Rudolf's needs.[3] In addition to providing these funds, Maizl also invited skilled Italian architects to work in Prague, giving the city its first buildings in the Italian renaissance style. As reward for his work, in 1598 Rudolf II granted Maizl and the Jewish Town several privileges. The most important was that no one could question Maizl's business transactions; the Emperor protected him against any accusations and complaints. He also guaranteed that Maizl could deal with his possessions freely and bequeath his property according to his wishes.

As a wealthy and privileged member of the Prague Jewish community, Mordechai Maizl significantly influenced and contributed to the development of the ghetto. One of his major undertakings was to build two new synagogues, both tax free. They are still standing and one bears his name. As a religious and pious man, Mordechai Maizl donated several Torah scrolls

The old ghetto before the clearance, photographed in about 1900. While Prague was on its way to becoming a major European city, the Jewish people living in the ghetto were still fetching water from the local pump.
Photo by Jindrich Eckert, courtesy Jewish Museum in Prague

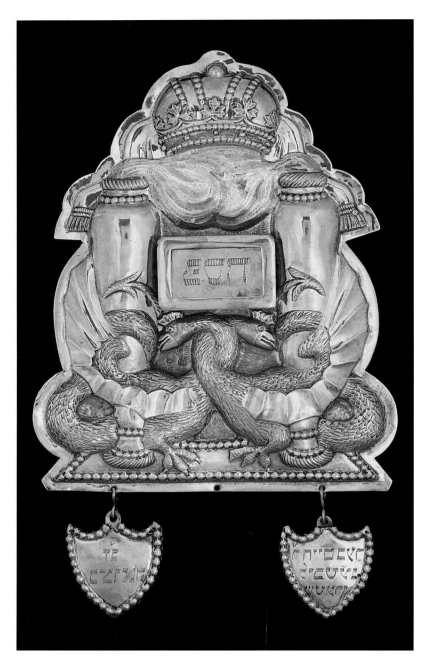

containing the basic ethical principles of the old rabbis.[4] The library in the Jewish Museum in Prague holds several copies of his work. He also worked to reform Jewish education. However, Rabbi Loew is mainly remembered in connection with the legend of the Golem.

It is said that when a wave of threats and pogroms rose again Jews in Bohemia, everyone turned to Rabbi Loew for help. One night, the Rabbi dreamed that he should create an artificial man to protect the ghetto, so the next day with the help of his son-in-law and one of his pupils, he formed the robust figure of a man in clay. Four hours after midnight Rabbi Loew brought the Golem to life with a magical *shem* — a parchment on which God's name was written in Hebrew — which he inserted into the Golem's mouth. The Golem slowly stood up, ready to do as his master ordered. He was like an ordinary man in every way except that he could not do anything on his own initiative — he only acted upon orders from his creator.

Rabbi Loew sent the Golem to guard the streets of the ghetto and if he saw someone trying to harm the Jews, he was ordered to intervene immediately. Before the Sabbath, the Rabbi always took the *shem* out of the Golem's mouth. However, one day he forgot to remove it, and while he was celebrating the Passover Sabbath in the Altneuschul,[5] the terrible news reached him that the Golem was on a rampage. The Rabbi hurried home and found everything destroyed. As he took the *shem* out of its mouth the Golem fell on the ground and the Rabbi could never wake him again. The Golem's body was taken to the loft of the Altneuschul where it ended as a pile of dust. The fear and vulnerability returned to the Jewish Town in Prague.

This legend was published in various forms and languages, and it influenced the writers Gustav Meyrink and Franz Kafka. Later it was an inspiration to theatre and film producers in Czechoslovakia and abroad. Rabbi Loew's impressive marble tombstone is of interest to all visitors to Prague's old Jewish cemetery.

and gold and silver ceremonial objects to the synagogues. Some are now major pieces in the collection of the Jewish Museum in Prague.

At around the same time as Mordechai Maizl lived in the ghetto, in 1574 Rabbi Judah Loew ben Bezalel, known as Maharal, came to Prague from Poland. He founded a Talmudic school and was later offered the post of chief rabbi, which he held until his death in 1609. Rabbi Loew was the ghetto's most important and original scholar. The inscription on his tombstone says that he was the author of more than fifteen works, printed in Prague, including commentaries on the Bible and the Sayings of the Fathers

The death of Rudolf II in 1612 marked the end of the ghetto's golden age. Change came in 1627 when Ferdinand II issued a degree that allowed Jews to learn various crafts and to sell products at markets outside the ghetto. In that same year the Guild of Shoemakers and Butchers, the oldest Jewish guild association in Prague, was established. Despite the many prohibitions and limitations still placed upon them, Jewish craft workers, in particular printmakers and embroiderers, produced artefacts of a very high standard, comparable with the quality of other European arts and crafts of the time.

As a result of the Thirty Year War (1618–1648) with the Austrian Hapsburgs, Bohemia was absorbed into the Austrian Empire. The German language became compulsory in schools and offices while Czech was considered to be the language of the peasants. During the war, the Jews contributed finances to the Hapsburgs and participated in defending Prague. In return the Prague ghetto received its own symbol — a helmet inside a Star of David.

The end of the Thirty Year War was followed by a long period of expulsions and struggle for the Jews. In 1670, Jews were expelled from Vienna and by 1680 over 7000 Jews from Vienna had obtained permission to settle in Prague. At the beginning of the eighteenth century, more than 11 600 Jews lived in Prague, some 30 000 in Bohemia and 25 000 in Moravia.[6] In 1726 a compromise was reached — Jews were allowed to stay in the country, but their numbers were limited as, in principle, only the first-born son was allowed to marry and have a family. Nevertheless, the Jewish population in Bohemia and Moravia rose considerably due to immigration from Poland.

The greatest change for the Jewish people came when the Austro–Hungarian monarch Joseph II came to power in 1780 and issued the Edict of Toleration. From then on Jews did not have to wear special marks of identity, were allowed to study law and medicine at universities, employ Christians, learn crafts from Christians,

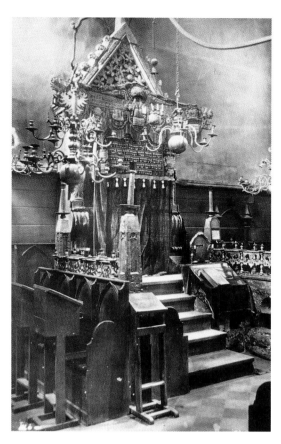

Altneuschul, about 1900. The *Aron ha-Kodesh* (Holy Ark), where the Torah scrolls are kept, is the most sacred place in a synagogue. It is adorned with a lavishly embroidered curtain (*parochet*).
Photo courtesy Jewish Museum in Prague

undertake most of the trades, rent (not to buy) land which they could farm, and serve in the army. However, instead of Czech and Hebrew names, Jews had to take German surnames and use the German language in schools and business. German became the language into which they translated Hebrew religious works and Judaic literature. This soon created a problem: with the strong influence of the German language, Czech Jews had to choose which nation they would support. Confusion and frequent conflict prevailed for a century as this account from the early 1920s illustrates:

> There was a German minority. I went to a German high school because it was considered a more thorough education, with liberal traditions. I grew up with both languages; it took me all my primary school to sort out Czech and German and not to mix the two languages … One of my father's best friends was what they called a Czecho-Jew. He was an assimilationist who went so far as to change his name to make it sound Czech.[7]

In 1867 Jews were granted complete civic equality and were allowed to settle and buy real estate outside the ghetto. This meant the end of the Jewish ghetto and it soon deteriorated into an unsafe and unhealthy slum inhabited by the

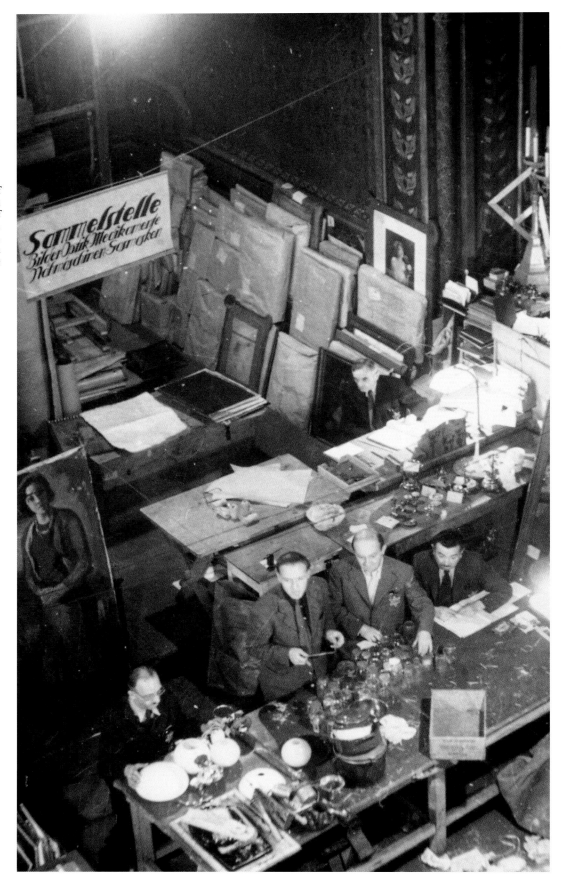

Registration of confiscated Jewish possessions in one of Prague's synagogues, 1942–1944.
Photo courtesy Jewish Museum in Prague

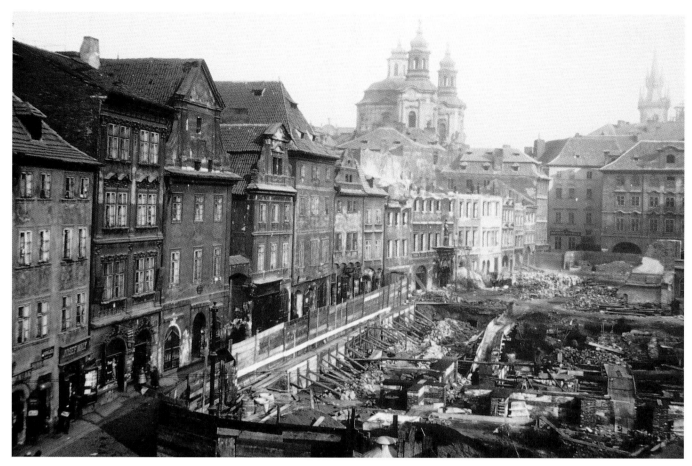

very poor. By 1917 Prague's old ghetto was demolished to give way to art nouveau buildings.

At the turn of the century most Jewish families in Central Europe lived a less traditional religious life than those from Eastern Europe. There Hassidic Jews lived like a closed nation, with their own religion, language, tradition, history, education, and myths. For the 35 000 Jews in Bohemia, there were many levels of being Jewish, from orthodox to accepting mixed marriages. Prague had a small circle of Zionists who dreamed of Palestine as a homeland for the Jewish nation, where Judaism would be a national religion and Hebrew a national language.

In the 1900s many Bohemian and Moravian Jews moved from the villages to the cities, to a new and faster life, to different daily worries, even different ways of thinking. These more worldly thoughts were not likely to be conducive to a religious life and some of the old customs began to appear awkward. The assimilation of Czech Jews was rapidly progressing. The well-known Czech Jewish writer František Langer recalls:

I still remember my father putting on the tefillin around his fatty arms every morning. Later, it was not as often and then only as an exception. He read the Hebrew prayers aloud, but he could not understand them any more. Fortunately, the Hebrew text was accompanied by a Czech translation.[8]

The younger generation quickly abandoned the religious life:

My father sent us children to Czech schools … we hardly learnt any Hebrew letters, later we only could admire the calligraphy of the Hebrew script … My last holy act was a reading from the Torah during my bar mitzvah. When I was preparing for it I had to transcribe the Hebrew letters to the Latin script.[9]

Soon sport begun to play an important role in the lives of young Czech Jews, and this together with other changes in the Jewish lifestyle meant that assimilation was unstoppable.

From the 1900s to the 1930s Prague was a meeting place for three cultures — German, Czech and Jewish. The development of German Jewish literature was concurrent with the

Clearing the Prague ghetto in about 1900. At this time three synagogues were also demolished and their inventory was rescued by Jewish scholars who founded the Jewish Museum in 1906.
Photo by Jindrich Eckert, courtesy Jewish Museum in Prague

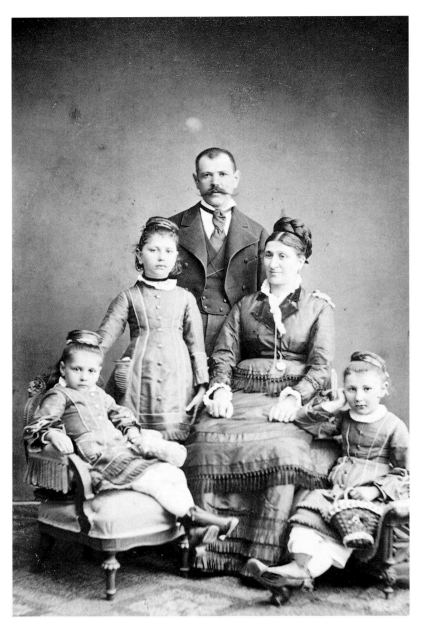

Jewish family, Prague, about 1900.
Photo courtesy Jewish Museum in Prague

development of Jewish emancipation and assimilation. Writer Franz Kafka (1883–1924), for example, was born only a few steps from the old ghetto, and grew up in a Czech–German Jewish environment.

With the collapse of the Austro–Hungarian Empire in 1918, the new Czechoslovakia was founded. Under the presidency of Thomas G Masaryk, the new state was composed of culturally different regions — Bohemia, Moravia, Silesia (a region north of Moravia, with a strong Polish influence) — and at the east, Slovakia and Ruthenia. Although the Czechs and Slovaks understand each other's language, the cultural and political history of Slovakia was entirely different from that of Bohemia and

Moravia. Before 1918 Slovakia was an integral part of Hungary, there were no Slovak schools and attempts to develop a Slovak national culture were suppressed. Assimilation had progressed in Bohemia much faster than in Slovakia or Ruthenia where the Jews maintained a strong religious life, characterised by the Hassidic traditions from the east, until the outbreak of World War II.

Close to 358 000 Jews lived in Czechoslovakia, when the thriving life of their Jewish community was so forcefully terminated in the spring of 1939.[10] Benedict David, a Holocaust survivor now living in Sydney who was nineteen years old at the time, remembers:

> I was told I couldn't go on attending the university because I was a Jew. That was 1939. I know that the invasion of Czechoslovakia took place on 15 March 1939. I remember the open roadster in which Hitler drove on that day … Until 1941 we were still relatively free to move and didn't wear yellow stars. We just had to move out of our flat and into a part of town where Jews were allowed to live and we had to share a two-room flat with another two families, in other words, one family in each room and the third family in the entrance hall. This was the beginning of [the] time of persecution. The deportation started in November 1941. I only have the memory of being selected for a transport and being put in a train with that one suitcase we were allowed and a day and a half later arriving in Theresienstadt with my parents. The younger ones — under fifteen or sixteen — were separated. Later, we were sent to Riga. I was in this train with my parents for five days and nights. We arrived [at] the station outside Riga; I was separated from them and have never seen them again. That was on 20 January 1942.[11]

Only a small percentage of Czech Jews were granted visas and were able to emigrate before the war. From November 1941 the Nazis deported Czech Jews to the death camps. Almost

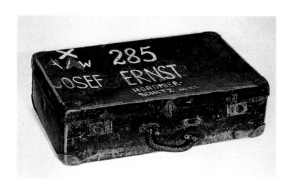

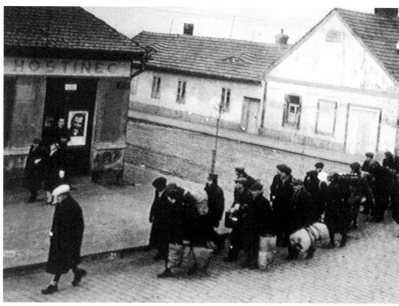

80 000 Jews were sent to Theresienstadt between 1941–1945, and from there they were sent east to the death camps. Jewish homes, synagogues and quarters were deserted. As tens of thousands of Czech Jews were sent to death, a handful of brave and dedicated Jewish scholars prepared and realised a heroic plan to save the historical and artistic legacy of the Jewish people under the direct supervision of Nazi officials. Most of the leading workers of the Central Jewish Museum were deported in the summer and autumn of 1944. The final wave of deportation took place in February 1945, three months before the end of the war.[12]

Education and knowledge have always been highly regarded in the Jewish community. Jews deported to death camps were allowed to take a small amount of luggage — which was confiscated on arrival — and some chose to pack prayer books and Judaic literature, instead of warm clothing and practical items. In more orthodox communities the book of God has always been treated with great honour and respect. For example, a prayer book should never be placed face down. If one drops a religious book, it should be picked up and kissed, likewise when one has finished reading it. It is a sin to throw a religious book or to place it under another object. Because religious books are used regularly they often become worn; then they must be buried in a cemetery.

The library of the Jewish Museum in Prague has been witness to the Jewish admiration of the written word. The core of the library, which today houses some 200 000 volumes, is a collection from the former library of the Jewish

community founded in 1857. At that time a Prague philanthropist, Issac W Taussig, donated over 150 rare volumes of Hebraic literature. Other important gifts to the library came from the Jewish publisher in Prague, Moshe Israel Landau (1788–1852); Prague Rabbi Shlomo Jehuda Rapoport (1790–1867) donated 3000 volumes; and Koppelmann Lieben (1811–1892), secretary of the Prague Hevrah Kadisha, donated 2500 volumes.

During the Nazi occupation, approximately 190 000 volumes were collected in Prague. To catalogue this vast collection of rare manuscripts and early prints, prayer books and Jewish religious literature, the confiscated material was taken to locations throughout Bohemia, including Theresienstadt, where a group of scholars and rabbis undertook the inventory and classification. Today, this unique collection includes 430 manuscripts, the majority are from the nineteenth to early twentieth century, 96 are from the eighteenth century, ten date from the seventeenth century, and eight volumes are from the thirteenth to the sixteenth century. Popular publishing is represented in the museum in the collection of the *Illustrated Jewish Folkscalendar* (published since 1852) and the *Illustrated Israelite Folkscalendar* (since 1881). These periodicals contain current news and popular articles, as well as highly academic articles on topics such as history and linguistics. Other subject areas found in the library collection include history, art history, linguistics, religion and literature, and academic Judaica and Hebraica.[13]

Immediately after World War II, the severely decimated Czech Jewish community attempted

(left) **The suitcase of Josef R Ernst from Horomerice, a small Bohemian town. He used it when he was deported in 1942.**
Photo courtesy Jewish Museum in Prague

(above) **A group of Jews being led to Theresienstadt from the Bohušovice train station in about 1942–1945.**
Photo courtesy Jewish Museum in Prague

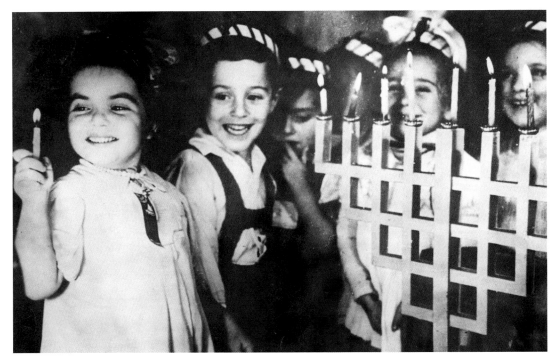

(right) Hanukkah **celebrations in a Jewish children's home, Prague, 1938–1940.**
Photo courtesy Jewish Museum in Prague

Synagogue grill, Prague, about 1750. The reading of the Torah scroll is essential to Jewish worship. The Torah is placed on a *bimah* **or reader's stand which is decorated with elaborate ironwork. This piece comes from the Cikánova Synagogue, which was demolished during the ghetto clearance in about 1900.**
Photo by Mark Gulezian, courtesy Jewish Museum in Prague and Smithsonian Institution, Washington

to re-establish itself, and by September 1945 some 50 Jewish communities had been formed. Those communities whose members did not return, or which did not have any resources, were disbanded. For the Jewish people the process of returning to a normal life was slow due to bureaucratic obstacles and protests from certain sections of the Czech population which had prospered from the Nazi confiscation of Jewish property. This process came to an end when the communist takeover in February 1948 stopped any attempts to re-instate the former democracy and the former way of life for Czech Jews. More than 10 000 Jews emigrated before and immediately after the February coup.

While the postwar democratic countries of the 1950s were welcoming the baby-boomer generation, the Czechoslovak nation entered into decades of communist terror and witnessed a series of political trials or 'monster processes'. Once the Communist Party gained unlimited power, it began a massive persecution of those who actually or allegedly opposed the regime. After February 1948 some 26 000 people were removed from political life and another 5000 from the public service, and more than 5000 students and professors were expelled from the universities. At the same time a quarter of a million new communist bureaucrats and labourers were appointed to the public service, the justice system and the army.[14] Religious life was also targeted; concealed anti-Semitism and open anti-Israeli politics were characteristic phenomena of the communist regimes in all Soviet satellite countries from the 1950s to the late 1980s.

Many of Czechoslovakia's leading communists were Jewish. The most notorious was Rudolf Slánský (1901–1952), who returned from exile in Moscow in 1945 as the newly installed

secretary general of the Communist Party. At the end of 1952 the country and the world were stunned by the allegation that Slánský and eleven other Jewish communists had been guilty of 'Jewish–Zionist' activities. Most were hanged.[15]

On the night of 21 August 1968, the armies of the Soviet bloc countries invaded Czechoslovakia and ended any hopes for liberalisation of the communist regime. It is estimated that about 6000 Jews left the country within a few months of the invasion. Those who were too young then, escaped illegally later. During the 1970s and 1980s anti-Israeli politics in Czechoslovakia escalated. The few Jewish functions and celebrations held at the historic Jewish Town Hall in Prague were infiltrated by the Czech secret police. Any contact with the Jewish world outside the Iron Curtain was regarded as a criminal offence and an anti-republic activity. Deteriorating synagogues and Jewish cemeteries around the country testified to this horrific chapter in Czech Jewish history.

Today the entire Czech Jewish community is estimated at between 2000 and 2500. Some 300 Jewish families live in Prague. Karol Sidon, former author, screenwriter and Charter 77 dissident, became the Chief Rabbi of Prague and the Czech lands in 1993. On his difficult work he comments:

> My biggest task is to persuade the Jews to be Jews — the resistance is obviously caused by the strong pre-war assimilation, by the Shoah (Holocaust) and communism. A typical full blood Czech Jew is a Jew who doesn't want to have anything to do with Judaism. It will take a long time and a lot of work to make our people to believe that they should stop comparing our community to the splendour of the pre-war one.[16]

Notes

1. Ctibor Rybák, 'Jewish Prague', *TV Spectrum*, Prague, 1991, p 10.

2. B Bondy, F K Dvorský, *K historii Zidu v Cechách a na Morave*, Václav Reznicek, Prague, 1906. Translated by J V.

3. J Hausenblasová, M Šronek, Urbs Aurea, *Prague of Emperor Rudolf II*, Gallery, Prague, 1997.

4. Otto Muneles (ed), *Prague ghetto in the renaissance period*, Jewish State Museum, Prague, 1965.

5. The Altneuschul (Old–New Synagogue) is one of Prague's oldest gothic monuments. Built in 1270, it was the spiritual centre of the Jewish community.

6. B Bondy, F K Dvorský, *K historii Zidu v Cechách a na Morave*, 1906.

7. Benedict David, born 1920 in Brno, Moravia. Interviewed by Eva Scheinberg and Katja Grynberg in Sydney on 13 July 1998.

8. František Langer, foreword to *Devet Bran*, Sefer, Prague, 1996. Translated by JV.

9. Ibid.

10. N Bergerová (ed), *Na krizovatce kultur*, Mladá Fronta, Prague, 1992. Of approximately 358 000 Jews, 118 000 lived in Bohemia and Moravia, 140 000 in Slovakia and 110 000 in Ruthenia. In 1939 Slovakia came under indirect German rule. Translated by J V.

11. Benedict David, interviewed by Eva Scheinberg and Katja Grynberg on 13 July 1998.

12. Arno Parík, 'The Jewish Museum in Prague', in Ctibor Rybák, 'Jewish Prague', *TV Spectrum*, Prague, 1991.

13. J Šedinová, 'Knihovna Zidovského muzea v Praze', unpublished paper, Prague, 1996. Translated by J V.

14. V Hejl, K Kaplan, *Zpráva o organizovaném násilí*, Sixty–Eight Publishers, Toronto, 1986. Translated by J V.

15. Ibid.

16. Karol Sidon, radio interview, Prague, March 1998. Translated by J V.

Suzanne D Rutland

THE JEWISH COMMUNITY IN AUSTRALIA

Compared with the span of Jewish history, Australian Jewry is a very young community, but its history has many fascinating aspects. Within two centuries it has emerged as one of the most vibrant of Jewish communities in the world.

A number of Jewish convicts arrived with the First Fleet in 1788, and by 1820 a few hundred Jewish people, mostly men, were living in New South Wales. The earliest Jewish organisation in Australia was the Jewish Burial Society formed in Sydney in 1817. Burial societies were quickly established in all the Australian colonies because carrying out a Jewish burial is considered to be one of the most important principles in Judaism. The first purpose-built synagogue in Australia was opened in York Street, Sydney, in 1844.[1]

Most of the early settlers were Anglo-Jewish, middle-class immigrants who transposed the English pattern of Jewish practice to Australia. English synagogues were modelled on the Anglican Church, with great stress on decorum and formality including choirs and sermons, and rabbis wore a 'dog collar' so that they looked like Protestant ministers. In 1878 the Great Synagogue in Sydney was consecrated with Rev Alexander B Davis, its first minister, following this pattern of Anglo-Orthodoxy. Its imposing structure remains an historic feature of the Sydney landscape.

In the 1840s, Jewish congregations were established in Hobart, Launceston, Melbourne and Adelaide. Victorian Jewry expanded rapidly as a result of the gold rushes and increased from 200 in 1848 to 3000 people in 1861. Jews settled in the gold rush towns of Ballarat and Bendigo, as well as in Geelong, and synagogues were soon built in those country centres. On the whole, Jews were well accepted into colonial society. In the 1860s a visiting rabbi from Jerusalem, Rabbi Jacob Levi Saphir, summed up this situation in his travelogue:

> There is no discrimination made between nation and nation. The Jews live in safety, and take their share in all the good things of the country. They also occupy Government positions and administrative posts. In this land,

they have learnt that the Jews also possess good qualities, and hatred towards him has entirely disappeared here.[2]

When Queensland became a separate colony, a number of Jewish families left Sydney for Brisbane, forming the nucleus of the Brisbane Hebrew congregation, which consecrated its synagogue in 1886. The first Jewish community in Western Australia was not formed until 1887 in Fremantle. A synagogue was opened in Perth in 1897. Synagogues were also built in the gold rush towns of Kalgoorlie and Coolgardie.

Jews participated in every facet of civic, economic and social life in Australia and prominent figures included politicians Sir Saul Samuel, Sir Julian Salomons and Sir Daniel Levy. In 1917 the New South Wales Legislative Assembly had to close on Yom Kippur because both the Speaker and Deputy Speaker were Jewish. Australian Jews contributed to the war effort during the First and Second world wars.

Australian Jewry was enriched by small numbers of refugees fleeing the Russian pogroms at the turn of the century, including businessman Sidney Myer, founder of what is now Coles–Myer, and by Polish Jews arriving in the 1920s. However, these 'foreign Jews' did not have a significant impact on the community. It was the Jewish refugees escaping from Nazism and Holocaust survivors who came largely from Central Europe in 1938 to 1939 and after 1945 who brought about the most dramatic changes. Between 1933 and 1954 Australian Jewry doubled in size from 23 553 to 48 436. Most of this immigration was based on family sponsorship and chain migration as reflected in the story of the Holocaust survivor Edith Sheldon (nee Drucker), who was born in Prague in 1927:

> I came on my own. I was 22. I used to work for HIAS, the Hebrew Immigrant Aid Society, in Prague as a secretary to the director and had the opportunity to see that I could apply for various visas. I got the Canadian and

Australian about the same time. I decided it's easier to be hungry in a warm climate than in a cold one. So I came to Australia and was able to get my mother out two years later.[3]

In all, a total of around 35 000 refugees and Holocaust survivors came to Australia in three main waves: 1933 to 1945, when 7000 to 8000 arrived; 1945 to 1954, when 17 000 arrived; and 1954 to 1961 when a further 10 000 arrived, particularly following the Hungarian uprising of 1956 and the temporary opening of the doors to Polish Jewry in 1958–1959. However, many more could have benefited from a new life in this country. Growing prejudice against Jewish migration and 'anti-refo' hysteria led to the introduction of quotas. At the Evian Conference held in France in June 1938 to debate the refugee problem created by Nazism, the Australian delegate, Colonel T W White (Australia's Minister for Trade and Commerce), commented that 'Australia has never had a racial problem and is not desirous of importing one'. After the war a series of restrictive measures were introduced including a quota which allowed only 25 per cent of all the passengers on any migrant ship from Europe to be Jewish. Later this quota was lifted but no more than 3000 Jewish Holocaust survivors were permitted to migrate to Australian each year. These policies were monitored through the 'Are You Jewish?' question on immigration forms.[4] Despite these restrictions, compared with other countries in the free world, such as the USA and Canada, Australia accepted the largest number of survivors on a proportional basis. Both Britain and South Africa accepted almost no Jewish Holocaust survivors after 1945.

Most Jews who migrated in this period came from Germany, Austria, Hungary and Poland. The number of Czechoslovak Jews was comparatively small. By 1939 only 244 had migrated to Australia,[5] joined by another 1000 between 1945 and 1954. The number peaked after 1968 when there were almost 2000 Czechoslovak Jews living in this country.[6]

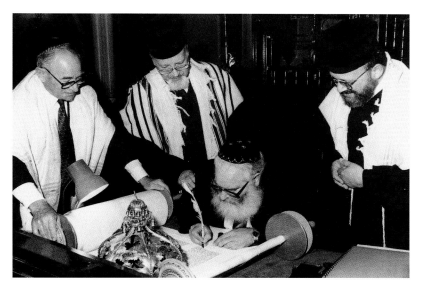

Rabbi Gerald Blaivas, a *sofer* or scribe, completing the last words in the Torah according to the Jewish custom. Rabbi R Apple is standing to his left and Rev E Belfer is watching him on the right. The Torah crown is in front of the scroll.
Photo courtesy *The Australian Jewish News*

While the percentage of Czechoslovak Jews in Australia is very small, a number have made important contributions to the development of both the Jewish and general communities. One significant personality is John Glass, who served as chair of the Overseas Jewry Committee of the New South Wales Jewish Board of Deputies in the late 1980s, playing a significant role in the campaign for Soviet Jewry.[7] John Glass was in Theresienstadt from the age of five until he was liberated at the age of eight. He was one of the 100 children who survived out of the 15 000 Jewish children who went through the concentration camp. On the bus taking the children to Theresienstadt he sat next to Pavel Friedmann who wrote the now famous poem 'The Butterfly'.

Most postwar Jewish survivors, especially those from Eastern Europe, arrived with a stronger sense of their Jewishness than those who had immigrated before the war, and could not relate to the assimilated local Australian Jewish community. Their influence contributed to a range of Jewish practices from the ultra-orthodox groups such as Adath Yisroel and the Habad movement to the Progressive movement. Nineteen Jewish day schools, part-time Jewish education programs, old age homes, communal fundraising groups, kosher shops and many

A group of school children from Mount Sinai College, a primary Jewish day school in Maroubra, Sydney, NSW, lighting the *Hanukkiah* in November 1993.

Photo courtesy *The Australian Jewish News*

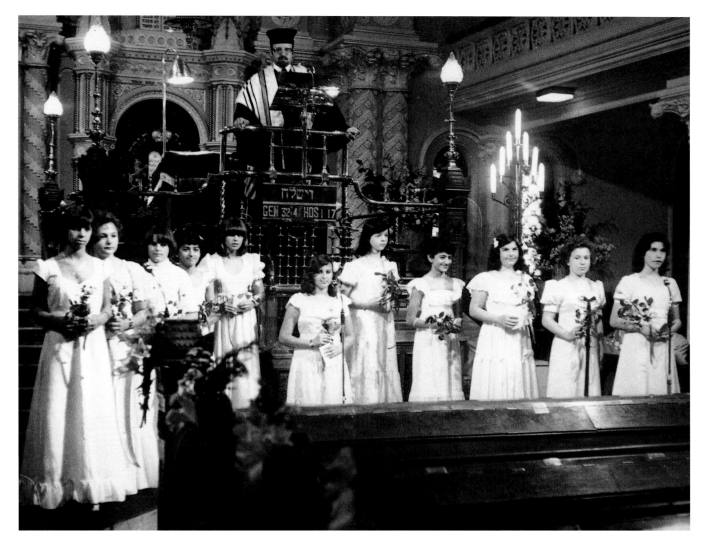

community and cultural organisations have been established in Australia. Yiddish culture is still alive, especially in Melbourne. The Zionist movement is very strong in Australia with bodies representing both local organisations and the international Zionist movement.

Most Jews in Australia observe some level of religious tradition and many are affiliated to orthodox synagogues. It is estimated that about 70 per cent of Australian Jews belong to a synagogue, 80 per cent fast on *Yom Kippur*, around 80 per cent attend a Passover home service and 70 per cent maintain some form of Sabbath observance such as candle lighting on Friday night. Circumcision and Jewish burial are widely practised.

In her biography, *Sister, sister*, of her mother and aunt, both of whom were Holocaust survivors, Anna Rosner Blay, a Polish Jew, recounts her mother's description of her family's level of Jewish observance in Krakow before the war:

We were not extremely observant Jews, but we went as a family to synagogue for the High Holidays. We lit the candles on Friday night, but didn't observe the rules against travelling and working on the Sabbath. Father covered his head only when he prayed …'[8]

This description would also apply to most Australian Jews today who are often referred to as 'three-day a year' Jews. On *Rosh Hashana*, *Yom Kippur* and first day Passover, at the central times of the service all Australian synagogues are full to overflowing and many run additional services in their communal halls to cater for the extra numbers.

Liberal Jews, who constitute about 20 per cent of Australian Jews, believe in retaining the basic moral concepts and obligations of Judaism and have modernised many of the religious practices as well as the synagogue service. The vast majority of Australian Jews are affiliated to orthodox synagogues yet are not strictly

Until recently most girls celebrated their *bat mitzvah* as a group, as seen in this photo taken at the Great Synagogue, Sydney, in 1977.
Photo courtesy *The Australian Jewish News*

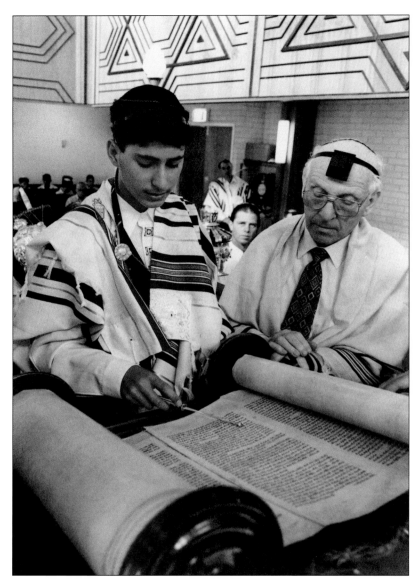

A thirteen-year-old boy being called to his first Torah reading at a *bar mitzvah* service at the Mizrachi Synagogue in Bondi, Sydney, December 1995.
Photo by Nathan Smith of ON 3 Productions

observant, which has led these people to be described as 'non-observant orthodox Jews'. An understanding of the Holocaust is a very important part of Australian Jewish identity. The development of Holocaust museum projects in Melbourne and Sydney was part of the increasing Holocaust awareness of the 1980s. In Melbourne a Holocaust Museum was opened in Elsternwick. In 1992 the opening of the Sydney Jewish Museum, dedicated to the Holocaust and Australian Jewish history and located in the historic Maccabean Hall, was a landmark event.[9] From the beginning, the Jewish Holocaust survivors have been the Sydney Jewish Museum's most important asset as voluntary guides and members of the museum's board. Also their association has its headquarters at the museum. They feel a strong sense of loyalty to Australia and are dedicated to passing on the

legacy. As Marika Weinberger, president of the Australian Association of Jewish Holocaust Survivors and Descendants commented: 'Our people did not share in the general euphoria at the end of the war ... We were a party to the war against Hitler, but we were not a party to the victory. For us victory came too late ...'[10]

The opening of the Holocaust museums in Sydney and Melbourne, as well as the Jewish Museum of Australia in Melbourne, was the beginning of a museum culture for Australian Jewry. It was followed in the late 1980s by a flowering of Jewish cultural and intellectual life previously unknown in the community. This has been fostered by the annual national conferences organised by the Australian Institute of Jewish Affairs and through visits to Australia by leading international Jewish thinkers and scholars.

The bicentennial activities in 1988, with the Melbourne Arts Festival and the *Old songs in a new land* exhibition at the Hyde Park Barracks in Sydney, as well as the publication of the first comprehensive histories of Australian Jewry by Hilary and W D Rubinstein in Melbourne and Suzanne Rutland in Sydney,[11] all provided a new focus and awareness of local Jewish history and cultural identity. Other important publications included Lysbeth Cohen's history of Jewish women in Australia, entitled *Beginning with Esther*, Arnold Zable's *Jewels and ashes*, Mark Baker's *The fiftieth gate*, Serge Liberman's various collections of short stories and Lily Brett's Auschwitz poems. In 1989 a new quarterly journal, *Generation*, edited by Mark Baker, was launched; a 'sign that the post-war Australian-born generation of Jewish writers and intellectuals is beginning a more active search for its own distinctive voice'.[12] In addition, the *Australia–Israel Review* has continued to be an important publication since it was established in the 1970s. The longest serving community paper is *The Australian Jewish News*, which celebrated its centenary in November 1995. This flowering has largely come from the second generation, university educated children of Jewish refugees

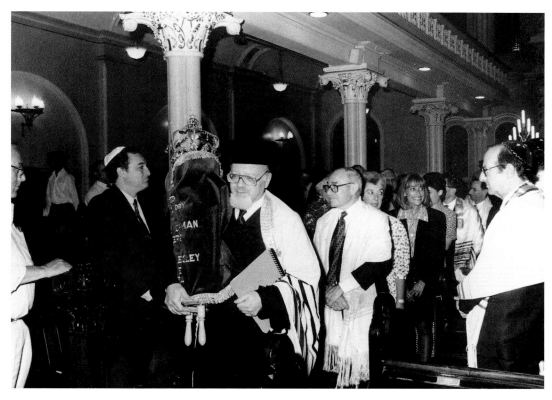

and survivors seeking an academic and intellectual understanding of their Jewish roots.

The total number of Jews in Australia today is estimated to be about 100 000.[13] The two largest centres, Melbourne (with a Jewish population of 40 000 to 45 000) and Sydney (35 000 to 40 000), dominate the scene. Each community has been moulded by its own ethnic composition. Melbourne Jewry has been significantly influenced by Eastern European Jews, especially from Poland, who were attracted by the development of Yiddish culture in Carlton since the 1920s. Later the epicentre moved to East St Kilda and Caulfield and, for the wealthier, Toorak. Polish Jews were more strongly committed to their Jewish heritage than Central European Jews. They brought with them diversity and at times also the divisions of interwar Jewish Poland, from the ultra-orthodox groups such as the Lubavitch Hassidim to the secularism of the left-wing Bundist movement.

In Sydney, Jewish culture has been influenced by the more assimilated culture of the Central Europeans — the Germans, Austrians, Hungarians and Czechs. A symbol of Sydney Jewry is the Hakoah Club in Bondi, a sporting and cultural club which has a membership of 11 000. South African Jews have also made a great impact in Sydney and Melbourne.

The demographic profile of postwar Jewish migrants indicated rapid social mobility. Many prominent Australian business people are Holocaust survivors, or the children of survivors, and have sought to repay Australia for the haven it has provided. This sense of haven was strongly conjured up by one Holocaust survivor, who wrote a description, 'On coming home', after a short time in Sydney as follows:

> It is a very peculiar feeling. It is almost midnight. We are in the middle of a city with two million residents. We are in Sydney. We are in Australia. You who were born here or have been living here for many years, you might not understand these feelings. Though it is midnight, though it is just our second day in Sydney, we seem to be at home. Already we start to have the same sense of security as all Australian citizens.[14]

Eva Engelman (nee Wertheimer), who was born in Prague in 1927, remembers her first impressions of Australia:

> Paradise. I was 19. Everything was so beautiful — the weather, the food, the freedom. I had difficulties getting on with young people, even with Jewish people. It was very difficult because we were so different. I couldn't understand their attitude to life. It took me a long while.[15]

Inauguration of a new Sepher Torah at the Great Synagogue, Sydney in December 1993. Rabbi Raymond Apple leads the procession carrying the scroll.
Photo courtesy *The Australian Jewish News*

Living in a free democratic society was important for all the Jewish people who have come to these shores since 1945, and they have sought to give as much as they could to their new country. This is reflected in Czech Holocaust survivor Judith Nachum's recollections of her first weeks in Australia:

> I left on my own in 1948. I went to Israel and stayed for 13 years. My family left Czechoslovakia in 1950. I came in 1961. By then I had a nine-year-old son. My mother gave me ten days to acclimatise. After ten days she said, 'You know enough English.' I didn't know any. 'Go and find yourself a job', which I did. I went to the city, went from one coffee lounge to another and got myself a job in the Strand Arcade. No English but in those days Australian people were very patient, and when they saw how hard I was trying, they were very, very helpful.[16]

The Australian Jewish community today is vibrant and diverse, representing a rich culture which reflects many parts of the Jewish world. From the black hats and traditional garb of Hassidim to the young people clustered around the pool tables in the Bondi Hotel, there are many ways of being Jewish. Yet there is a commonality and sense of community which ties these diverse groups together. When Jewish communities in other parts of the world are faced with tragedy, or there is an event to celebrate, Australian Jewry joins together. For example, in Melbourne the Concert in the Park, held at Caulfield Park each March, attracts an audience of 10 000 to 15 000, representing the full spectrum of Jewish life. The Jewish people who migrated to Australia before and after the Holocaust brought with them their European Jewish culture, the 'precious legacy' which has greatly enriched not only the Jewish community, but the broader community as well.

Notes

1. For more detail, see J S Levi and G F J Bergman, *Australian genesis: Jewish convicts and settlers, 1788–1850*, Rigby, Adelaide, 1974.

2. As quoted in Suzanne D Rutland, *Edge of the diaspora: two centuries of Jewish settlement in Australia*, second edition, Brandl and Schlesinger, Sydney, 1997, p 73.

3. Edith Sheldon interviewed by Eva Scheinberg and Katja Grynberg in Sydney on 6 July 1998.

4. For more detail see *Edge of the diaspora*, op cit, pp 231–244.

5. See Charles Price, 'Jewish Settlers in Australia', *Australian Jewish Historical Society Journal*, vol 5, part 8, 1964, Appendix II, III (a) and (b).

6. Hilary and W D Rubinstein, *The Jews in Australia: a thematic history*, volumes I and II, William Heinemann Australia, Melbourne, 1991, table 2.2, part 2, 1961–1986, p 87.

7. S D Rutland and S Caplan, *With one voice: a history of the New South Wales Jewish Board of Deputies*, Australian Jewish Historical Society, Sydney, 1998.

8. Anna Rosner Blay, *Sister, sister*, Hale & Iremonger, Sydney, 1998, p 27.

9. *The Australian Jewish News*, Sydney edition, 20 November 1992. Ibid.

10. Rutland and Caplan, op cit, p 350.

11. See Hilary Rubinstein, *Chosen*, Allen & Unwin, Sydney, 1987; S D Rutland, *Edge of the diaspora*, William Collins, Sydney, 1988, and Hilary Rubinstein and W D Rubinstein, *The Jews in Australia*, volumes 1 and 2, William Heinemann Australia, Melbourne, 1991.

12. *Australian Jewish Times*, 20 October 1989.

13. Census figures are, however, increasingly inaccurate as statistics of the Australian Jewish population; an upward correction of about 30 per cent is necessary.

14. *Sydney Jewish News*, 11 August 1950.

15. Eva Engelman interviewed by Eva Scheinberg and Katja Grynberg in Sydney on 9 July 1998.

16. Judith Nachum interviewed by Eva Scheinberg in Sydney on 14 July 1998.

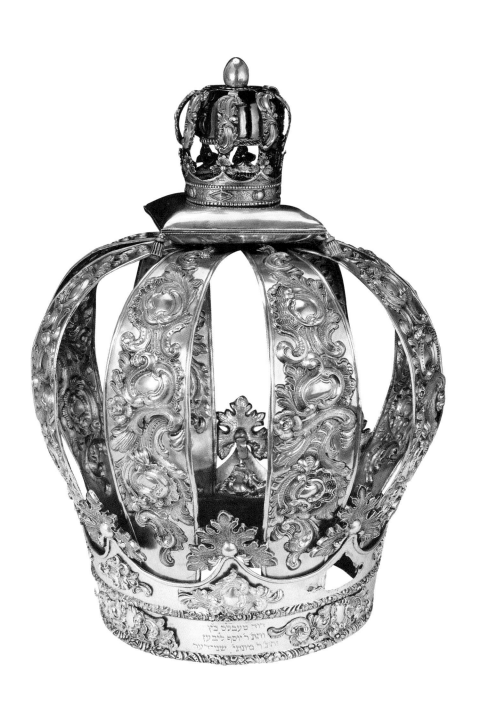

Notes:

The translation of Hebrew inscriptions has been taken from D Altshuler (ed), The precious legacy: Judaic treasures from the Czechoslovak State Collections, Summit Books, New York, 1983.

See 'Jewish calendar' in Glossary for explanation of the dates of objects.

Synagogue

Torah

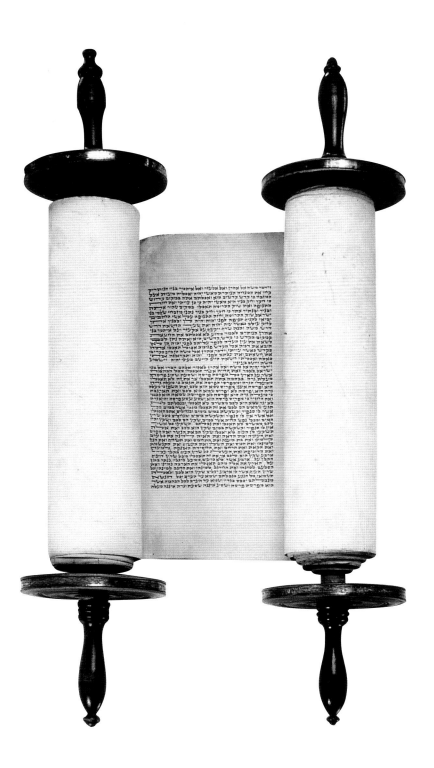

Torah scroll, Bohemia or Moravia 1863–1864. Reading from the Torah is a central feature of the synagogue service. Written on parchment according to precise rules, the Torah scroll contains the Five Books of Moses, the *Pentateuch*. Elaborate textiles and silver decorate the scrolls. This Torah is from the community in Boskovice, Moravia, which had a significant synagogue built in 1698. After World War II the synagogue's condition deteriorated as it was used for industrial storage; however, it was restored in the 1990s. 5369

The collection of Torah curtains, mantles, valances and other textiles, such as binders, shawls and covers, is one of the most valuable assets of the Jewish Museum in Prague. Many of the textiles come from Prague and represent a continuous range from the end of the sixteenth century to the 1930s.

Synagogue textiles

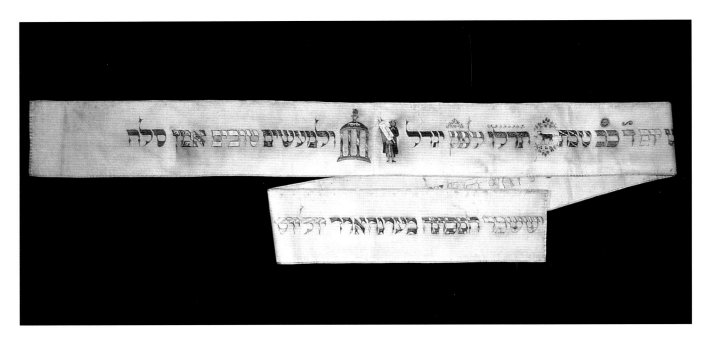

(above and right) **Torah binder, Frankfurt (?), 1876. Painted linen. A long wrapper (*mappah*) is used to hold the Torah scroll together when it is not in use. Although rarely seen because they are hidden under the mantle, some binders are works of art. This one was painted by the mother of a newborn boy and donated to the synagogue after his circumcision. Detail *(right)*.** 687/72

(opposite page) **Torah curtain, Prague, 1685–1686. Richly decorated textiles have been used in Jewish religious ceremonies since ancient times. This embroidered curtain protected the Holy Ark in a Prague synagogue. Its inscription reads: 'The donation of Isaac ben Lipman Hazzan Kohen Poppers of blessed memory and his wife Temerl, daughter of Hirsch Perlhefter, "to glory in the work of her hands"'.** 16 703

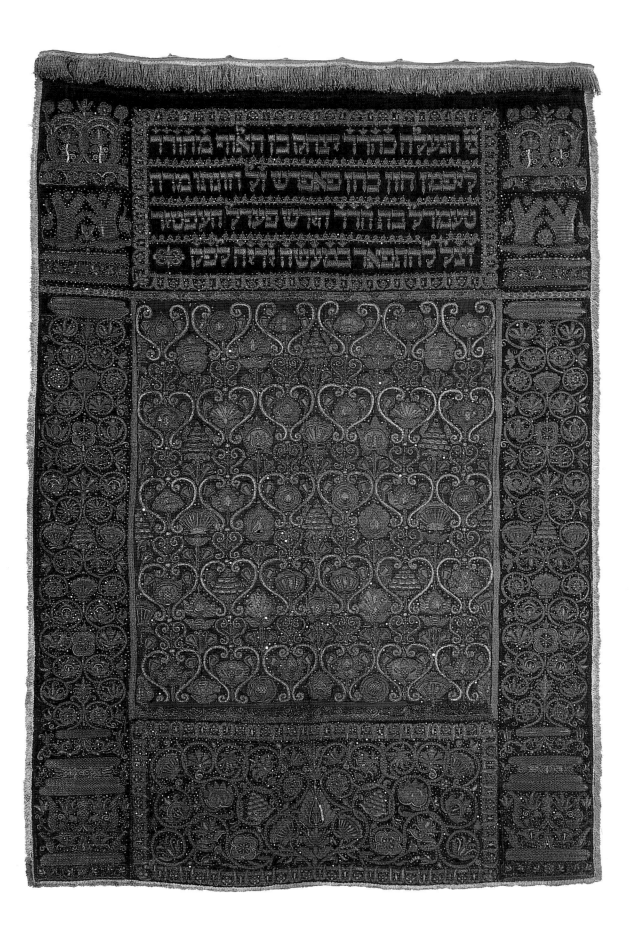

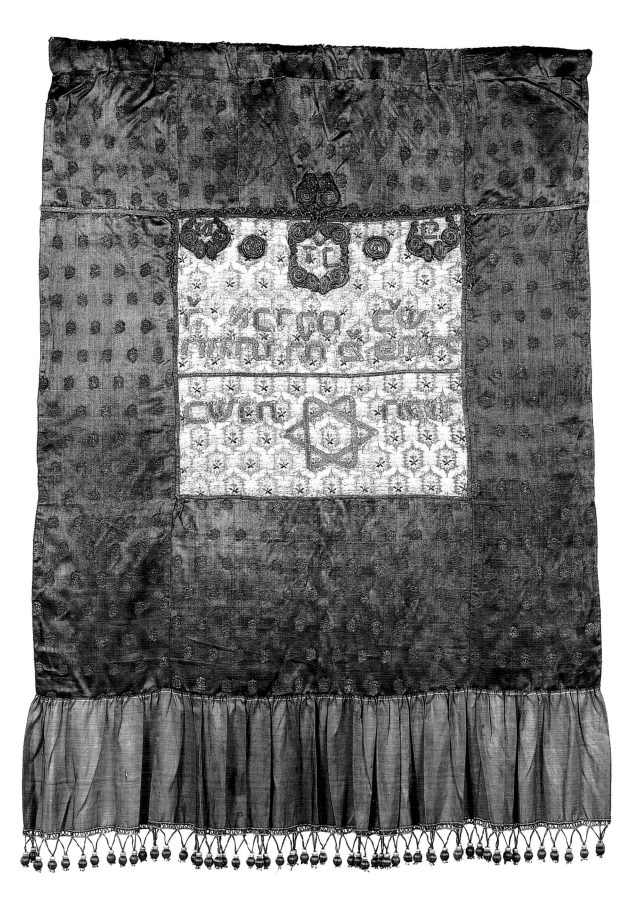

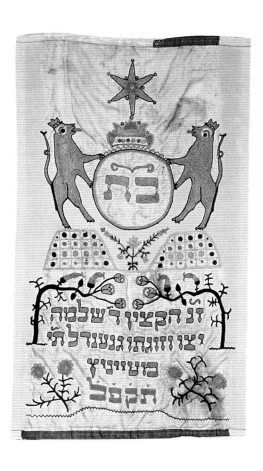

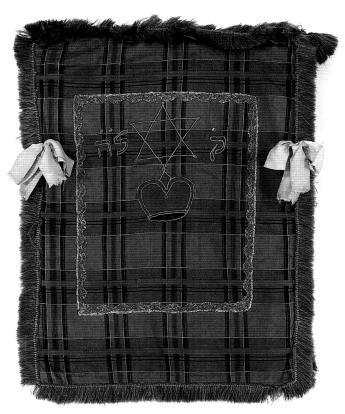

(opposite page) Torah curtain, Moravia, 1813–1814. This silk embroidered curtain was donated to the synagogue in Boskovice. Its background fabric was imported from Italy in about 1620–1640. Such a lavish gift is an indication of the importance of the Moravian Jewish communities from the late 18th century on. 2900

(left) Torah mantle (detail), Bohemia, 1819–1820. The heraldic lions and floral motifs on this embroidered silk mantle resemble those on Bohemian folk embroideries. It is an example of a gift made in the home for use in a synagogue. 52 713

(below) Torah mantle, Bohemia, late 19th century. This simple mantle, with its silk embroidered Star of David and appliqued stylised Torah crown, was used in the synagogue in Kolín, an important centre of Bohemian Jewish culture since the early 15th century. 71 211

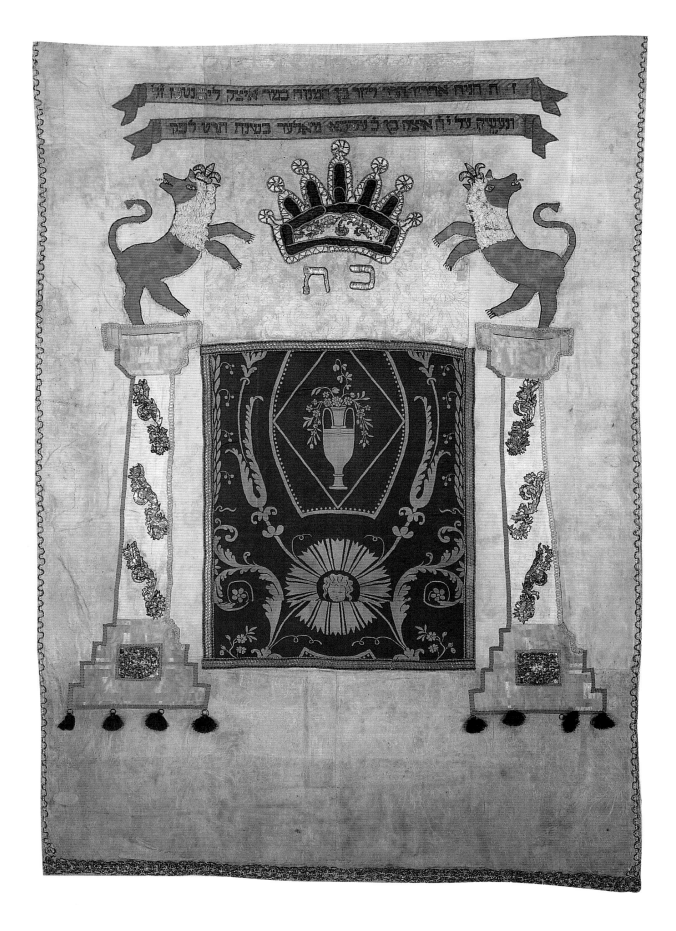

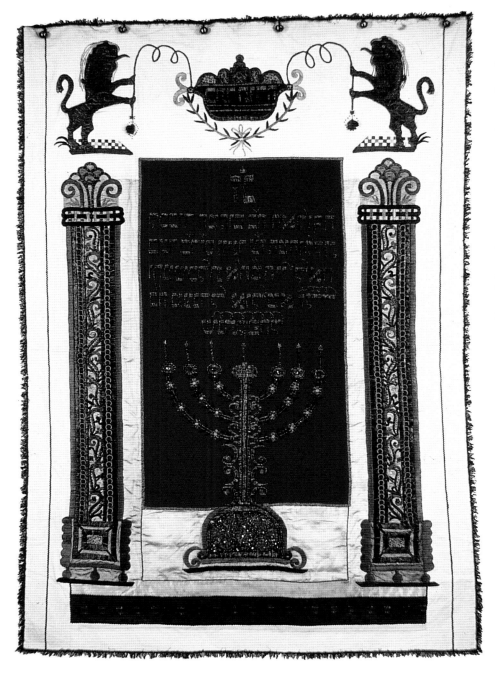

(opposite page) **Torah curtain, Moravia, 1849–1850.** This curtain was sent to Prague's Central Jewish Museum from Mikulov, one of the most important Jewish settlements in Moravia since the mid 14th century. Between 1553 and 1573, Rabbi Judah Loew, well known as a scholar and creator of the Golem, held the post of the chief rabbi of Moravia. This curtain shows the strong influence of local folk art. 3420

Torah curtain, Moravia, 1824–1825. An early example of 'portal' composition curtains. Their design shows a liberation from formal patterns and reflects local folk embroidery. The stylised heraldic lions and the large *menorah* embroidered in silk are similar to the local folk style of flat and linear embroidery. 7596

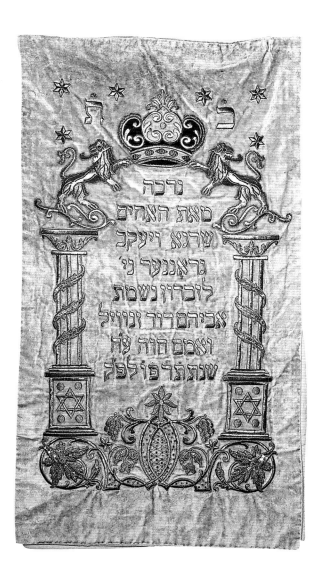

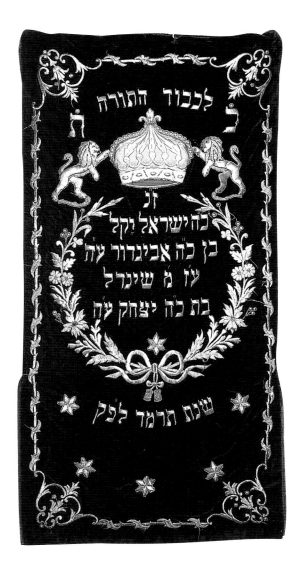

(left) **Torah mantle, Moravia, around 1900. This white velvet, richly gold embroidered mantle came to the Central Jewish Museum in Prague from Moravská Ostrava, an important Jewish community since the 18th century.** 71 149

(right) **Torah mantle, Moravia, 1884–1885. From the late 19th century many synagogue textiles were produced in factories or in professional workshops. The mix of traditional symbolism and forms with the style of the period is apparent on this gold embroidered velvet mantle dedicated to the synagogue in Kyjov, a small Jewish settlement destroyed by the Nazis during World War II.** 32 100

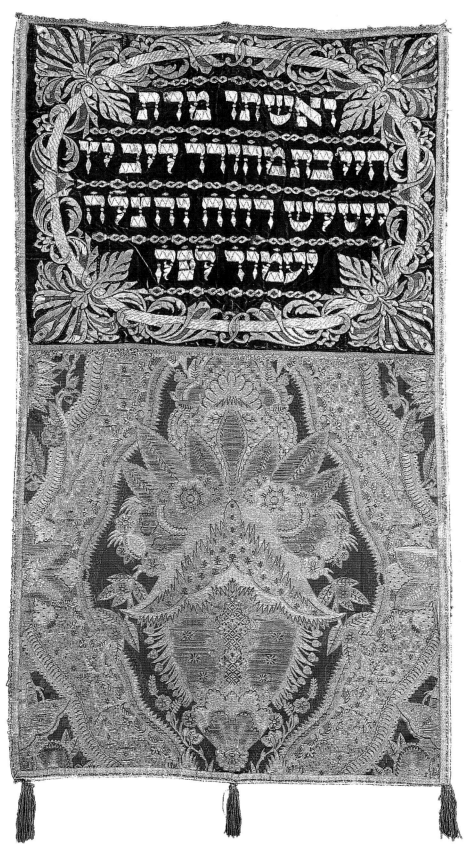

Torah mantle, Prague, 1725–1726. A Torah scroll is carefully wrapped in a fine fabric mantle and stored in the ark when it is not being read. This elaborate mantle of silk velvet embroidered with metallic threads was donated by David and Haya Katz to the Pinkas Synagogue in Prague.

12 664

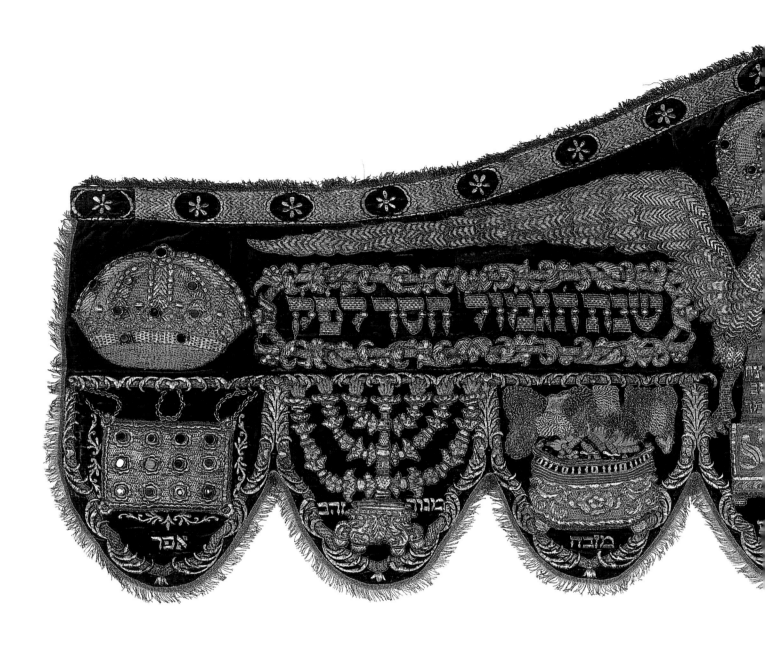

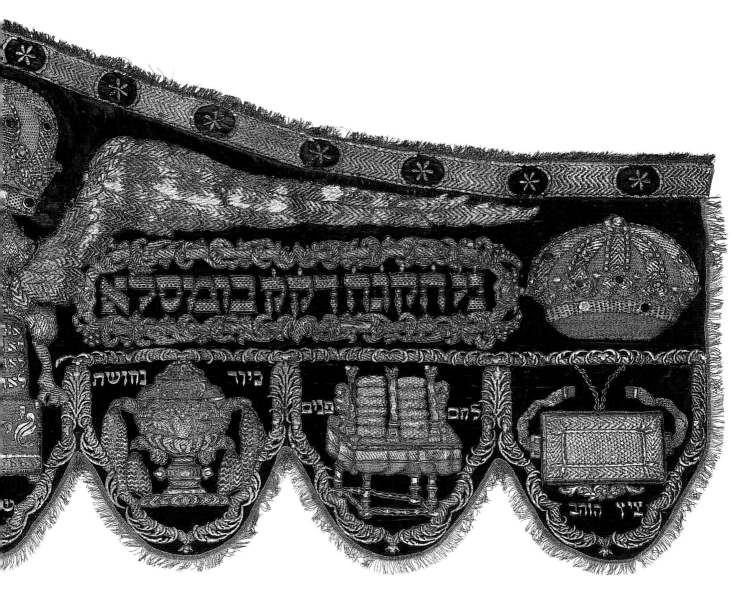

נחושת כיור

לחם

זהב ציץ

Torah valance, Prague, 1718–1719. From the mid 17th century, in Bohemia and Moravia an extra valance, called a *kaporet,* was hung above the curtain. According to its inscription, this valance was commissioned by the burial society for a synagogue in Mladá Boleslav, Bohemia. It bears symbols of the Torah and items from the Jerusalem Temple: (from left) a priestly garment (*ephod*); a seven-branched candelabrum (*menorah*); the altar; the tablets of the Ten Commandments (*Decalogue*); showbread; a bronze basin (*kiyor*); offering; and the high priest's golden plate. 2243

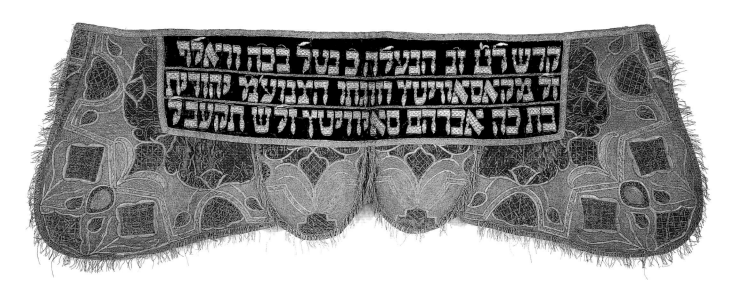

קדש ל"ט ז"ב הנעלה כ טיל בכה הראלף
דל מקאסאורישטל הווחרו הצנועל שחודטיה
בת כה אברהם סאהרשטיל ש חקעב"פ

(top) Torah valance, Austrian Empire, 1730–1731. It is not known exactly where this embroidered silk velvet valance was made, but according to its inscription it was owned by the Burial Society of Mikulov, Moravia, in 1761–1762. The rich floral decoration on this valance contrasts with the symbolism in the embroidered designs of earlier pieces. 5166

Torah valance, Bohemia, 1811–1812. An inscription in decorative Hebrew calligraphy has been used in place of the rich designs seen in earlier textiles. The valance was donated by Nettel and Judith Wolf to a synagogue in Breznice, Bohemia, which was in use until the 1930s. 59 890

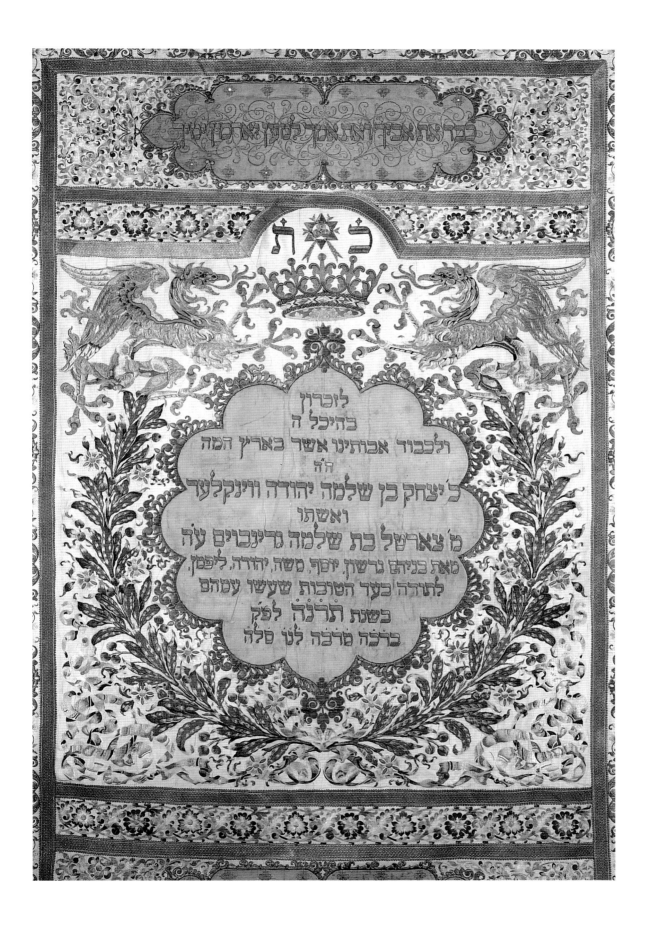

בוראת אבן ואת אבן לטען ואדן יטיך

כ ל ת

לזכרון
בהיכל ה
ולכבוד אבותינו אשר באריק המה
ה"ה
ר יצחק בן שלמה יהודה ווינקלער
ואשתו
מ' צארטל בת שלמה גרינבוים ע"ה
מאת בניהם גרשון, יוסף, משה, יהודה, ליפמן,
לתורה כער הטובות שעשו עמהם
בשנת תר"נ"ה לפ"ק
ברכה מרבה לנו סלה

Torah mantle, Moravia, 1867–1868. White is symbolic of purity and is the colour of the vestments used during the holy days of Rosh Hashanah and Yom Kippur. This white silk damask and gold embroidered mantle came from the synagogue in Boskovice. The double-headed eagle is an Austrian imperial symbol often used by Jews as an expression of gratitude for tolerant treatment. 2783

(previous page) Torah curtain, Salzburg, 1894–1895. Created in Salzburg, Austria, by a group of women embroiderers, this exquisite silk curtain was donated to the synagogue in Miroslav, Moravia, by Gerson, Joseph, Moses and Judah Lipman. The synagogue, built in 1845, was converted into a community centre after World War II. 7228

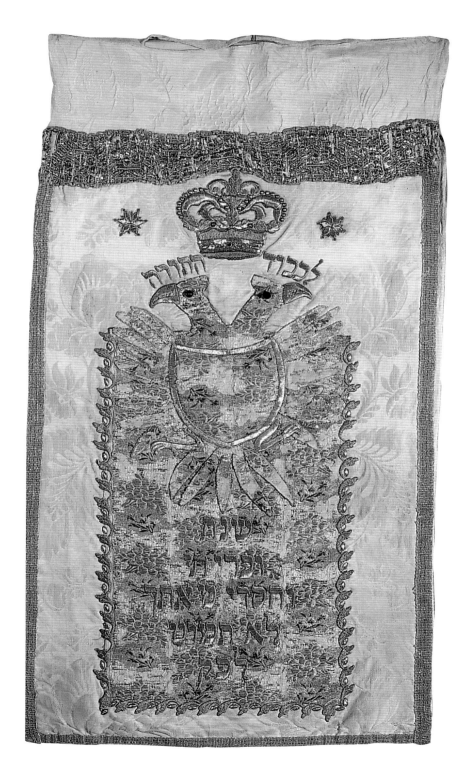

A crown, symbol of royalty and the wisdom of the Torah decorates the top of a dressed Torah scroll. Crowns are made of silver and often of a significant size. The adorning of the Torah has been known since the middle ages but the oldest preserved crown in Prague dates to early eighteenth century.

Crowns

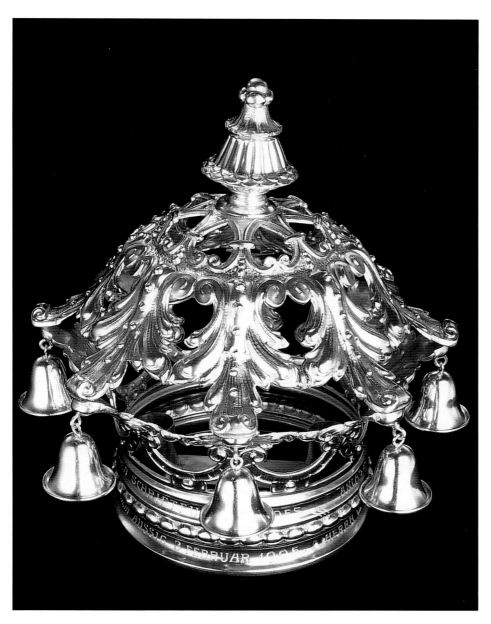

Torah crown, Prague, 1872–1882. This cast and engraved silver crown has bells attached to it to evoke respect from the congregation during the Torah procession in the synagogue. It carries the following inscription: 'Dedicated by the Israelite Women's Association of Ústí nad Labem [Bohemia] on 3rd February 1905 on the occasion of the 70th birthday of its secretary Mr Lowy Hammerschlag'. 37 443

The oldest decoration of the Torah were the finials (*rimmonim*), mentioned by Maimonides, the great Jewish thinker of the twelfth century. These pairs of Bohemian silver finials of the eighteenth and nineteenth centuries represent three styles.

Torah finials, Prague, 18th century. Repoussé, cut-out silver. Shows style using round crowns at the top. 37 571 a,b

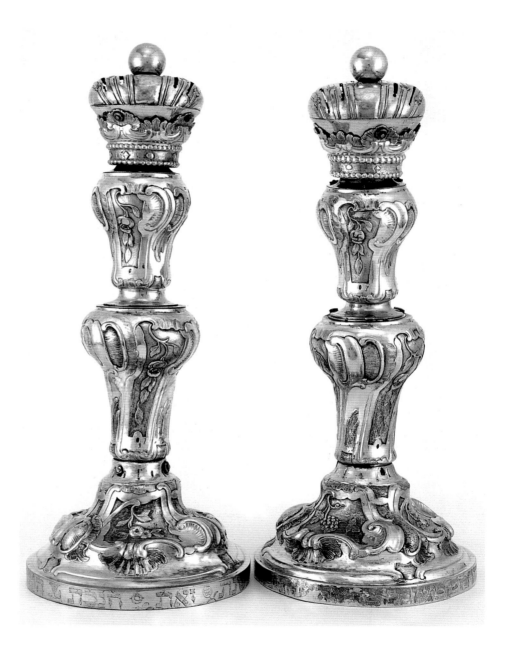

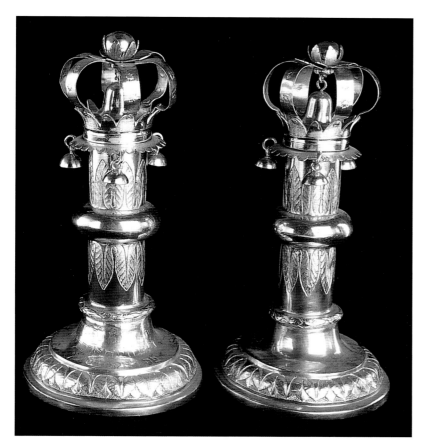

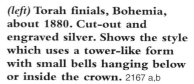

(left) **Torah finials, Bohemia, about 1880. Cut-out and engraved silver. Shows the style which uses a tower-like form with small bells hanging below or inside the crown.** 2167 a,b

(below) **Torah finials, Bohemia, 1900. Cut-out silver. Typical of the style used in Prague and Vienna characterised by small bells. They draw on the fine work of Italian silversmiths.** 4383 a,b

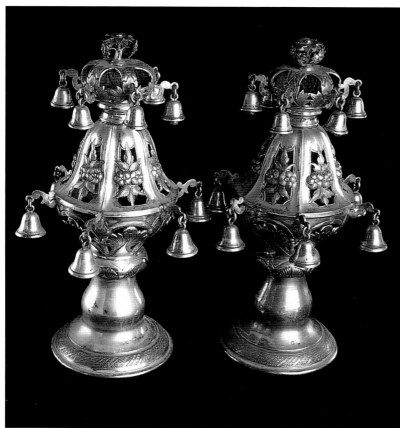

A silver shield, or breastplate (*tass*), is hung by a chain on the Torah mantle as a reminder of the shield worn by the high priest in the Temple in Jerusalem. A common decoration on Bohemian shields were the temple pillars flanked by lions. Most shields were produced by a combination of several silversmithing techniques including hammering, repoussé, engraving and gilding.

Torah shield, Prague, 1816. Repoussé and engraved silver. The maker of this exquisitely crafted shield was the famous Prague silversmith Thomas Höpfel (1793–1847). The imperial crown symbolises the crown of the Torah, as well as referring to the tolerant treatment of the Jews by the emperor. The inscription reads: 'Made from charitable funds'.
44 162

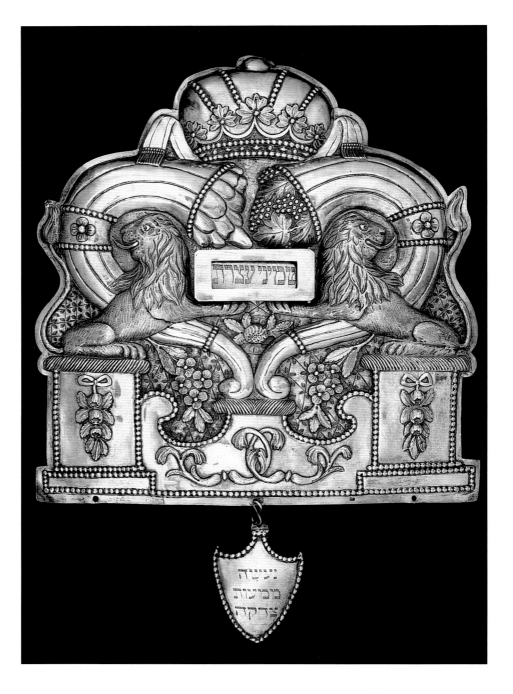

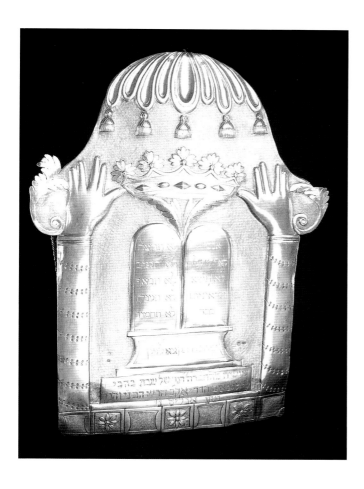

(left) Torah shield, Vienna, 1813. Donated to the Old Synagogue in Brno, Moravia. The stylised design on this shield is reminiscent of the simple designs seen on Moravian textiles of the early 19th century. 7128

(below left) Torah shield, Prague, 1831. Another unique example of Höpfel's work, which combines repoussé, hammered and engraved silver. This shield is notable for its unusual iconography and full, baroque forms. The dedication appears on two small suspended shields: 'This was donated in the will of Hayim Ber Lichtenstern'. 174 189

(below right) Torah shield, Prague, 1816. The contrasting textures of the silver, the robust lions and the unusual iconography are characteristic of the work of its maker, Thomas Höpfel, a well-known silversmith working in Prague. Due to various restrictions, Jews often had to order the Torah decorations from other silversmiths. 37 603

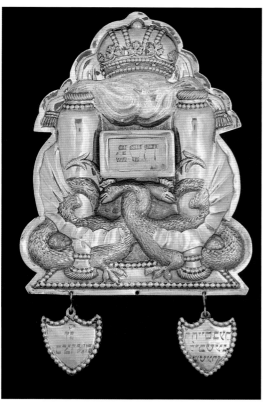

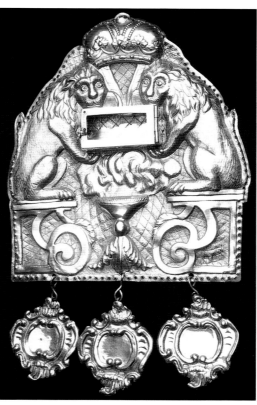

To avoid touching the Torah scroll with the bare hand, the reader uses a pointer (*yad*). The handle of the pointer is finished with a hand with a bent or outstretched finger, with or without a ring. The majority of pointers from the nineteenth century are made of silver plate and engraved. However, pointers made of carved wood, ivory and coral were also common.

Pointers

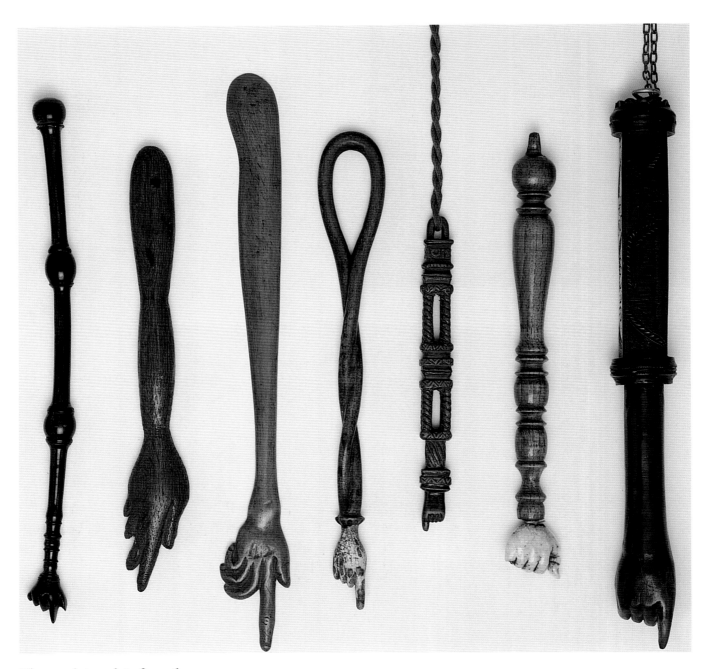

These pointers date from the mid to the late 19th century and come from Bohemia and Moravia.

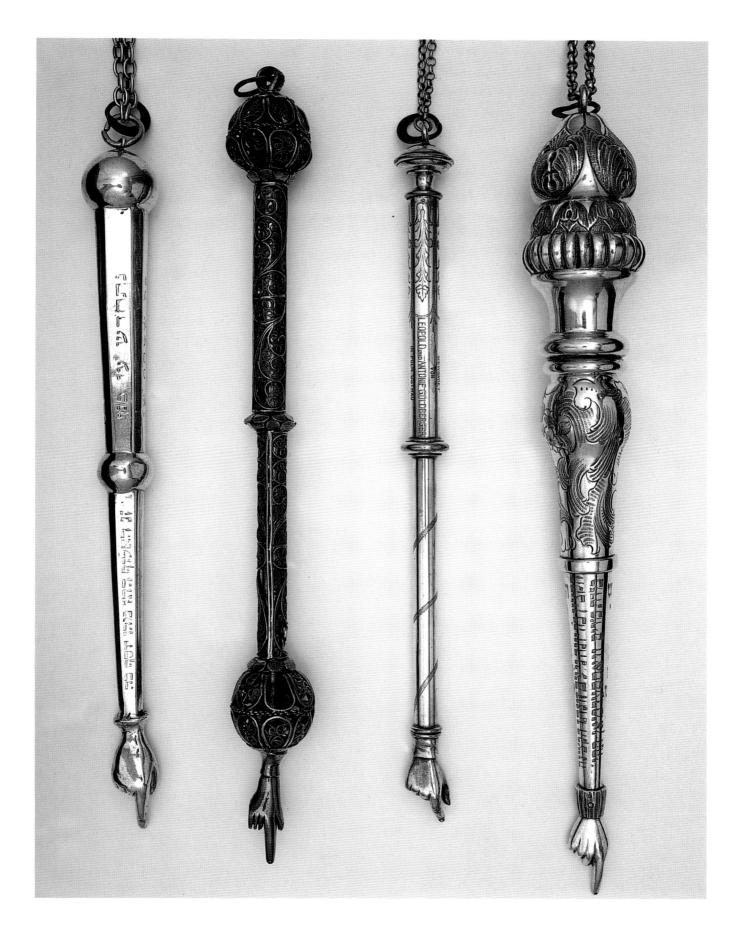

The Jewish Museum in Prague's collection includes rare synagogue equipment and a variety of implements and objects such as large alms boxes, a synagogue clock and Levite sets created by both amateur and highly skilled craftspeople.

Alms box, Bohemia–Sušice, early 19th century. A rare example of a synagogue charity box. Its form, almost unknown outside Bohemia, suggests a possible reference to medieval arm reliquaries which were used in Germany and Bohemia. The inscription reads: 'A gift in secret pacifies anger' (Proverbs 21:14). 66 127

Alms box, Bohemia, early 19th century. This robustly carved wooden box comes from Kasejovice, where Jewish settlement dates to the late 16th century. Kasejovice became well known when Filip Bondy, supposedly the first rabbi in Bohemia to preach in the Czech language, lived there in the late 19th century. 9720

Synagogue key, Prague, late 19th century. This large cast-steel key probably belonged to the Maisl Synagogue in Prague. Each circle of the trefoil is decorated with a Star of David. 37 534

Eternal light, Prague, late 19th century. In front of the Ark in the synagogue hangs the eternal light (*Ner tamid*), a symbol of the constant presence of God. Glass lights for the synagogue are rare; this example is made of Bohemian clear and ruby glass. 32 916

(opposite page) **Synagogue clock, Bohemia, about 1870.** Clocks and watches with Hebrew dials date back to the 18th century. This richly embellished clock from the Písek Synagogue has Roman numerical dials under painted Hebrew inscriptions indicating the time for different prayers throughout the day and week. 23 412

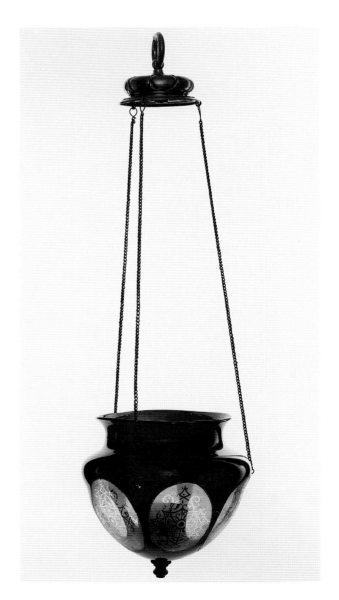

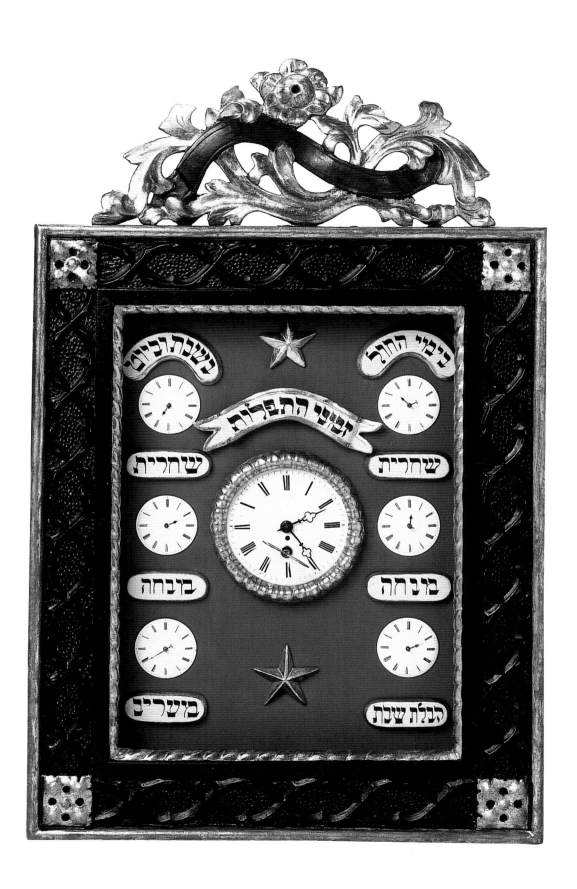

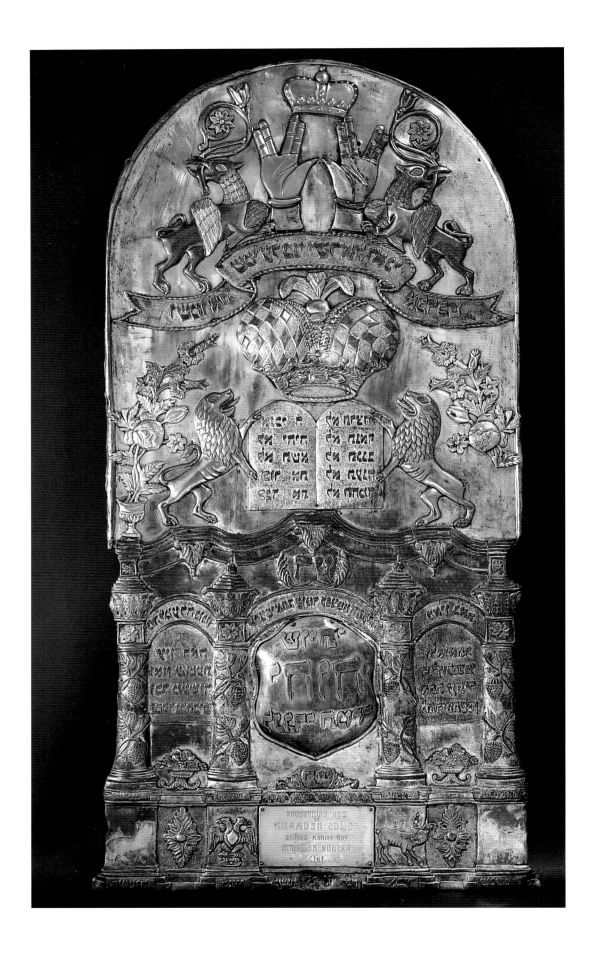

(opposite page) *Shiviti* plaque, Moravia, 1879–1880. This monumental, silvered and brass stippled plaque, measuring over a meter in height, was sent to Prague from Frýdek–Místek, northern Moravia, where Jewish families were allowed to settle only from the mid 19th century on. The *shiviti* plaque, placed near the officiant's desk in a synagogue, contains a verse from Psalm 16, 'I have set (*shiviti*) the Lord always before me'. 1797

Shiviti plaque, Bohemia, 1821. A very different example of a *shiviti* comes from Dobríš. A paper cut-out and colourfully painted plaque in an Oriental style, it is richly decorated with floral ornaments and Judaic symbols: a *menorah*, heraldic lions, columns and doves. 8089

Ceremonial beaker, Eastern Europe, about 1850. The prayer of sanctification (*Kiddush*) is recited over a beaker of wine before the Sabbath and festival meals. This repoussé and engraved silver cup would have been a treasured family possession. The rather crude and robust engraving indicates its possible rural provenance. 174 348

Levite set (laver and basin), Prague, 1818. Since biblical times, the Levites have had the honour of ritually washing the hands of the priests, *Kohanim*. This elegant silver laver in the empire style contrasts with the refined simplicity of the basin. 37 707 a,b

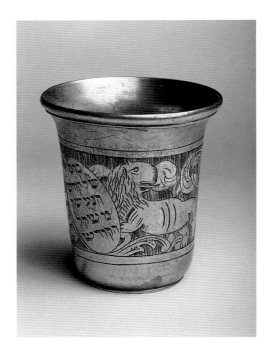

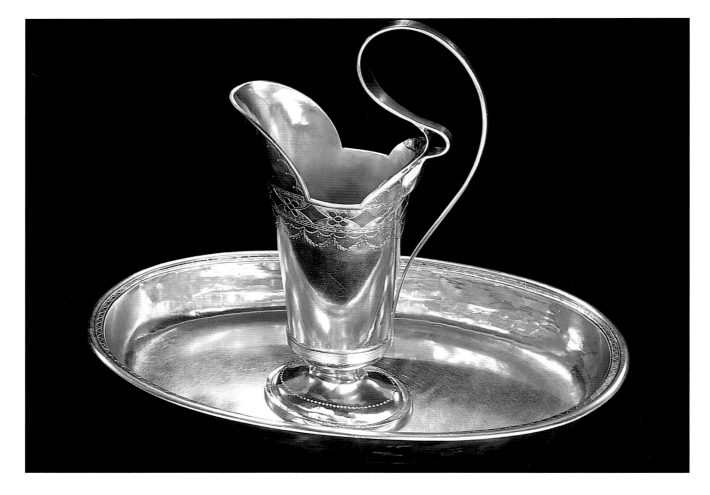

Torah curtain hooks, Bohemia, 1840–1841 *(above)* and 1828–1829 *(below)*. Painted wood, iron hook. Both items come from Loštice and are rare examples of the ingenious equipment used in some synagogues. Still bearing traces of their original gilding, the hooks are decorated with simple ornamental motifs.

54 536/2, 54 536/3

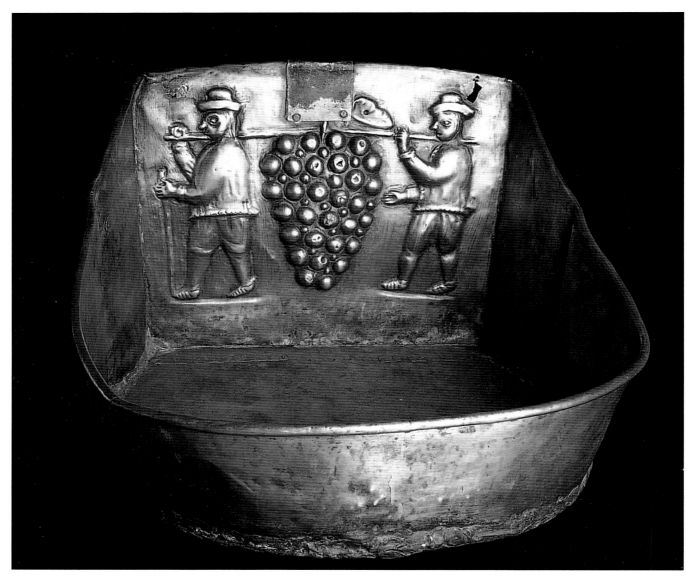

Basin for *lavabo*, **Moravia, 18th century. A basin and** *lavabo* **are usually placed at the entry to the synagogue for hand washing before the service. The rustic decoration of this cast and hammered copper basin from Valašské Meziříčí is inspired by the region from which it came: South Moravia is renowned for its vineyards.** 23 194

Family and community life

The Jewish Museum in Prague holds a collection of ritual and everyday items that were used in Jewish homes, including *mezuzot* and kitchen implements such as spoons, graters, forks and rollers. Perhaps more than any other part of the museum's collection these objects eloquently tell of the horror of the deportation of Jewish people to the death camps, leaving thousands of homes deserted.

Mezuzot **are long and narrow and contain a small parchment scroll. As Jews are commanded to attach the word of God to their doorposts and gates,** *mezuzot* **are affixed to the right doorpost. Most surviving examples, such as these, are made of wood.**

(left) *Mezuzah*, **Bohemia or Moravia, 19th century. Carved and stained wood case used in the Klaus Synagogue, Prague.** 66 483

(right) *Mezuzah*, **Bohemia. This** *mezuzah* **is significant because of its form and carving. Made at the beginning of the 19th century, it was part of the Jewish Museum collection established in 1906.** 32 129

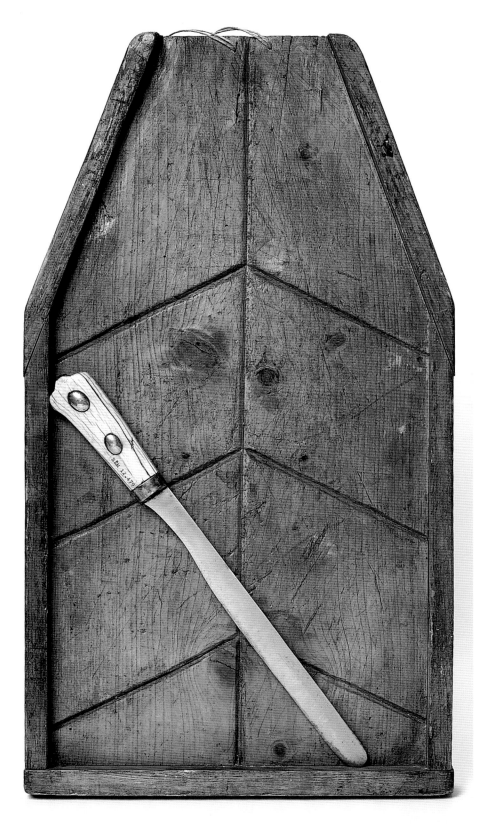

(opposite page, above) **Spoons and supper fork, Bohemia, 19th century. Carved wood.** 23 806 a, 23 806 b, 23 805 b

(opposite page, below) **Cream whisk and pastry mould, Bohemia, 19th century. Carved and stained wood.** 2453, 173 602

Koshering **board with slaughtering knife, Bohemia, late 19th century. For meat to be ritually correct (***kosher***) the animal or bird must be slaughtered according to strict rules using a** *chalaf*, **an exceptionally sharp knife. After the slaughtering, the meat is soaked and salted to remove blood which must not be eaten. The special board facilitates the drainage.** 50 717 a (knife), 91 922 b (board)

(right) *Matzah* cover, Bohemia, late 19th century. The Passover-eve ceremony, the *Seder*, involves every member of the family. It includes the narration of the Exodus from Egypt and features the eating of the *matzah*, the unleavened bread, which was baked hard by the sun as the Israelites escaped from their taskmasters. Like the *hallah* cloth for Sabbath, Bohemian and Moravian *matzah* covers are delicately embroidered. 95 522 K

(below) *Matzah* roller, Bohemia, early 19th century. A rare example of a household item owned by a Jewish family. 7580

(opposite page) Plate, Bohemia or Moravia, about 1815. This cast and engraved pewter plate is a puzzle to art historians. The engraving of a semi-naked woman on a Judaica item is probably unprecedented. The scene depicts Potiphar's wife trying to seduce Joseph. The Hebrew inscription around the plate reads: 'But he refused. She caught hold of him by his coat. But he left [his coat in her hand] (Genesis 39:7, 8, 12)'. This plate was part of the Jewish Museum collection established in 1906. 37 696

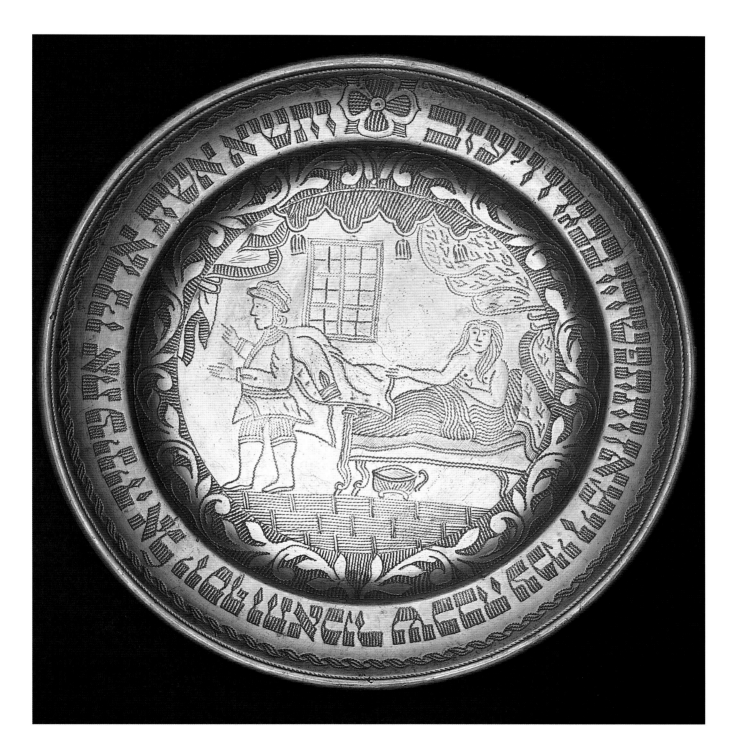

The rhythm of the week builds up to the celebration of the Sabbath, commencing at sunset on Friday. After the Friday evening service in the synagogue, the focus shifts to the home as the Sabbath is welcomed by the family with the prayer of sanctification (*Kiddush*) over a cup of wine, followed by a blessing and two loaves of plaited bread (*hallah*) which are covered with a decorated cloth. In Bohemia the cloth is often embroidered linen.

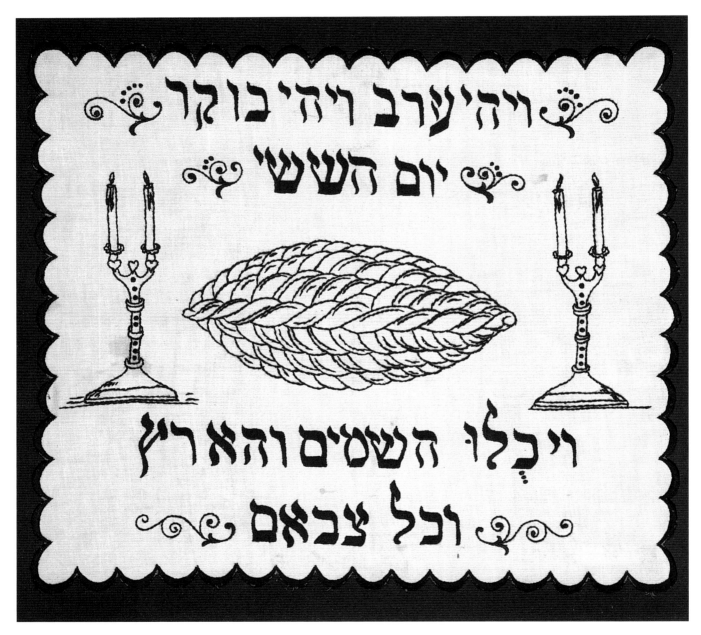

Hallah **cover, Bohemia, 19th century. Embroidered linen.**
17 151 K

Kiddush **cup, Bohemia, 19th century. Painted glass.** 95 800 b

Sabbath plate, Central Europe, about 1900. Porcelain with colour print. 12 904

The scent of fragrant spices, usually cloves, is consolation for the departure of the Sabbath. The spices (*besamim*) are kept in decorated cases, generally made of silver. In Bohemia and Moravia they come in a great variety of forms, often in the style of miniature gothic towers. In Eastern Europe the spice boxes are more often in the shape of fruit, flowers or animals.

Spice box, Central Europe, about 1900. Filigree and cut-out silver. 173 725

(opposite page) **Spice box, Moravia–Brno, 1856. Filigree and cut-out silver.** 12 269

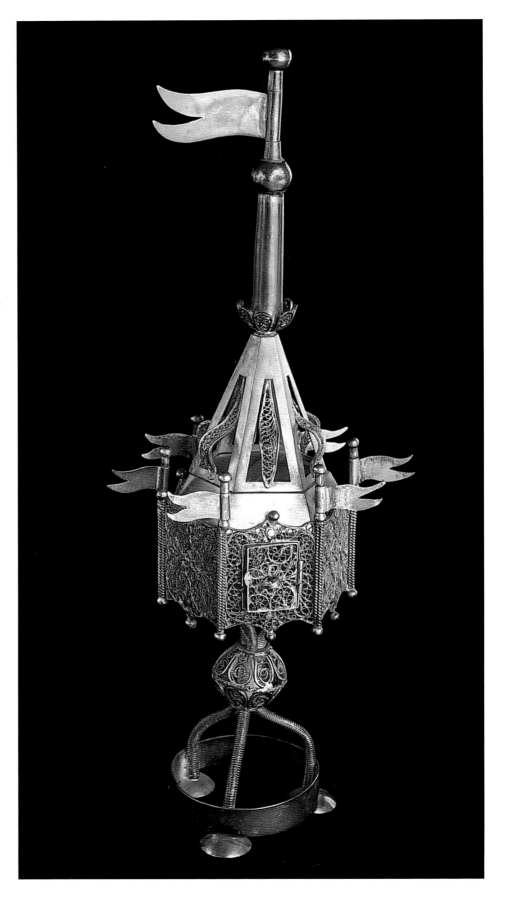

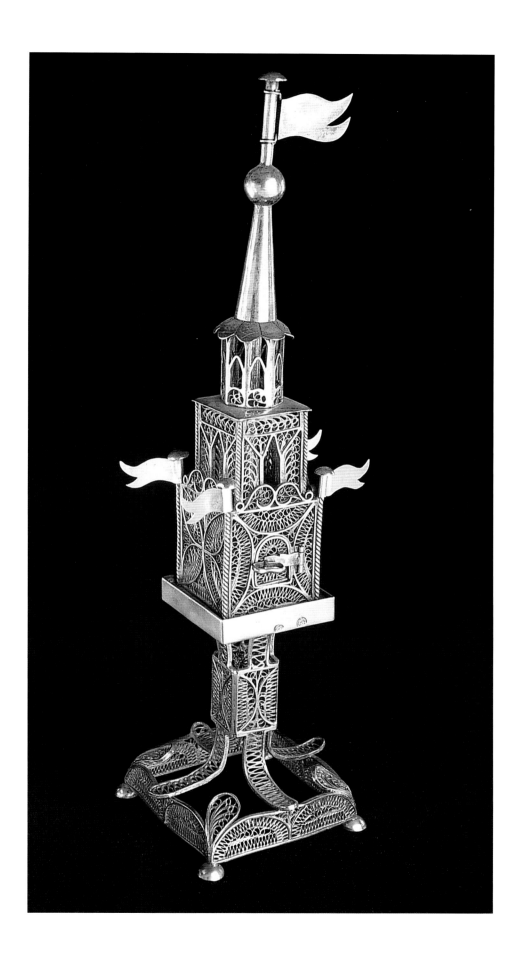

(right) **Spice box, Eastern Europe, late 19th century. Cast and cut-out silver.** 102 004

(below) **Spice box, Eastern Europe, late 19th century. Cast and engraved silver.** 173 916

(opposite page) *Havdalah* **candles, Bohemia, 20th century.** 2/88

At the end of the Sabbath, the *Havdalah* ceremony includes the lighting of a special candle braided of several strands of coloured wax. The candle has several wicks whose flames merge to form one large flame. Often the youngest person present holds this 'torch'.

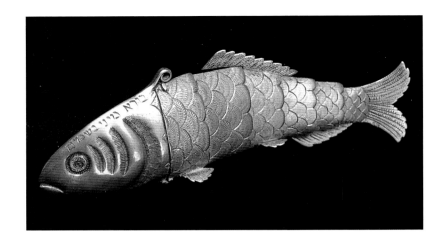

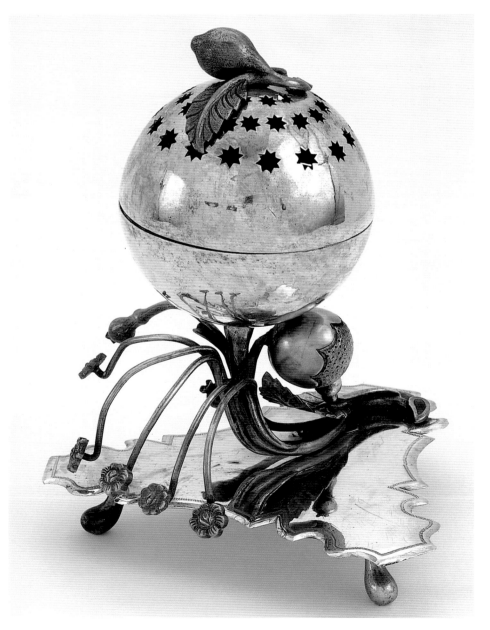

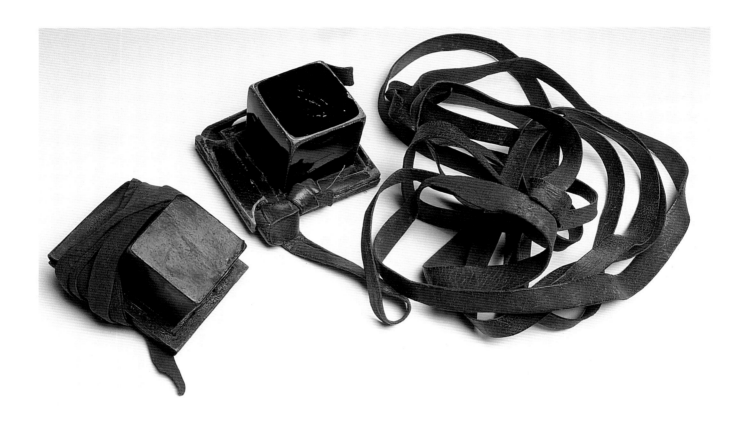

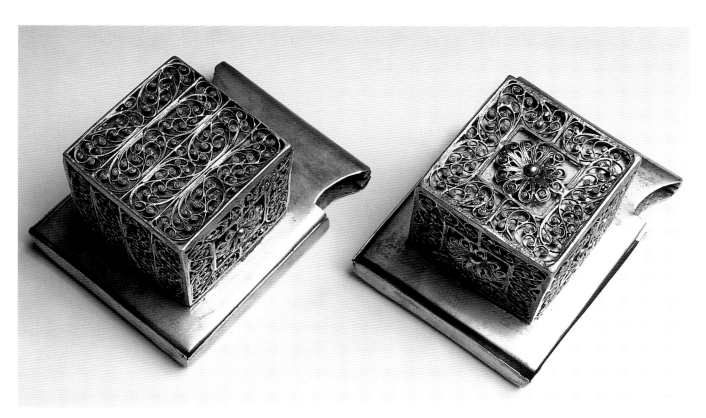

Tefillin or phylacteries are the black leather boxes containing passages from the Torah which a Jewish man ties to his head and arm for morning prayers. Additional metal containers were made to protect the boxes when they were not in use. Silver cases were made mainly in Poland and were decorated with fine filigree work.

(opposite page) *Tefillin*, Bohemia, 20th century. Leather and parchment. 186/94 a, 185/94 b

(above) *Tefillin* containers, Poland, early 19th century. Silver filigree. 3976, 3956

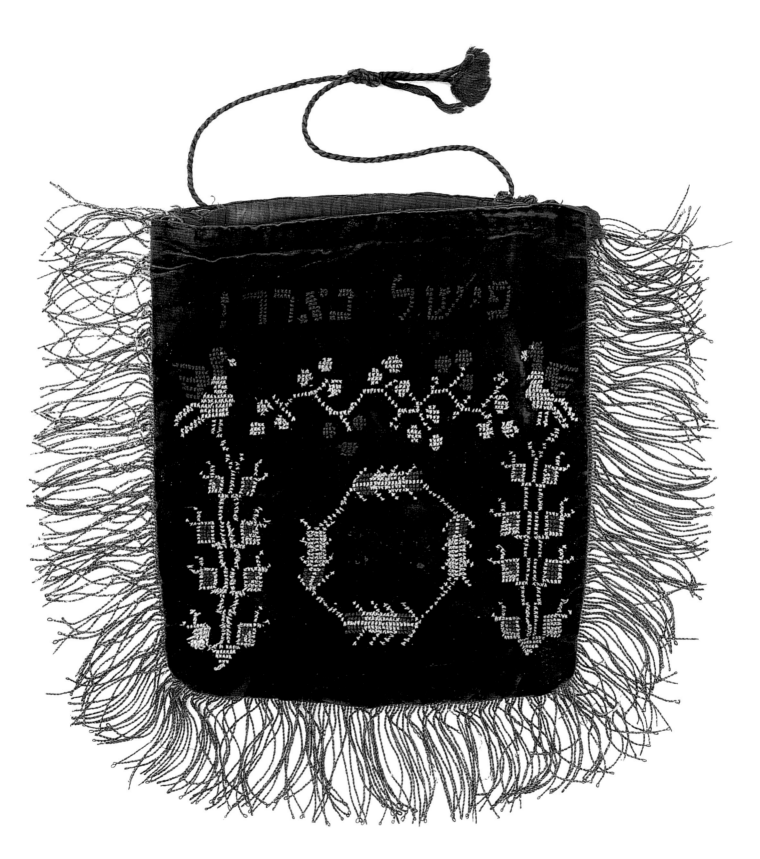

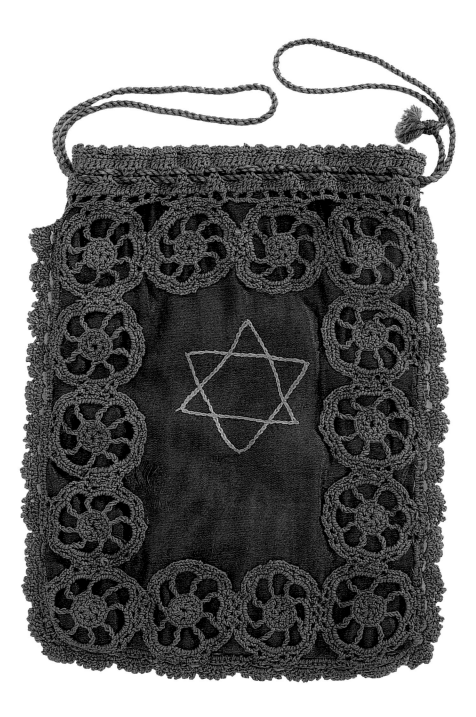

Some *tefillin* bags are quite simple, decorated with initials or a Judaic symbol, but these two examples are elaborately embroidered and crocheted, traditional techniques in Bohemian folk art.

(opposite page) Tefillin bag, Bohemia, 1893. Embroidered velvet. 401/72

Tefillin bag, Bohemia, late 19th century. Crocheted cotton on silk. 363/72

A Jewish man or boy covers his head with a skullcap, known as a *kippah* or *yarmulke*, during religious worship or study.

Skullcap, Bohemia, 19th century. Velvet embroidered with cotton threads; linen lining with leather band. 27 053 b

(below) Skullcap, Bohemia, 19th century. This embroidered silk-velvet skullcap with its gold tassel more closely resembles a Turkish fez than the smaller caps worn today. 22/73

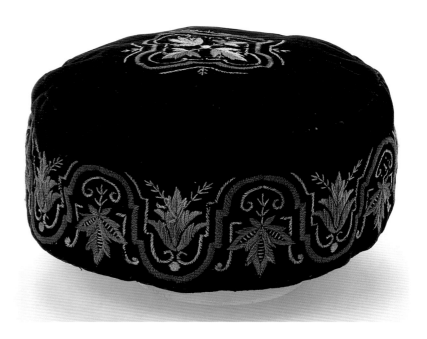

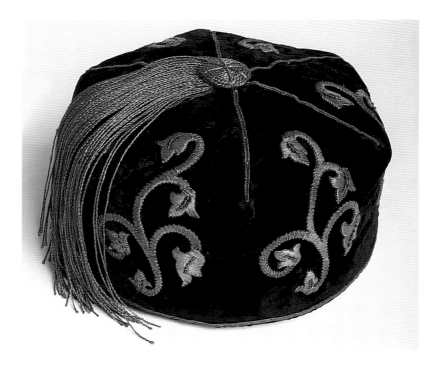

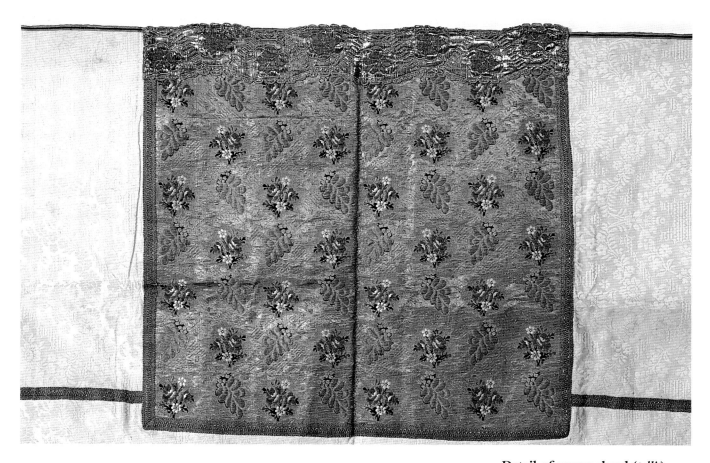

Detail of prayer shawl (*tallit*), Bohemia, late 18th century. A *tallit* is a fringed shawl worn by men and boys for morning prayers in the synagogue or at home. This fine example is made of white silk damask (probably from Germany) with an overlaid panel of floral silk brocade from France. 19 344

Boys are named at their circumcision, a ceremony that takes place on the eighth day after birth. The circumcision is carried out by the *mohel*, a pious man with the required medical and religious expertise. The naming of a girl takes place when the father is called to the reading of the Torah on the first Sabbath after her birth.

Circumcision

Circumcision instruments, Prague, mid-late 19th century. Silver.

From left:
Vials, Prague (?), mid-late 19th century. White metal; silver. 61 945, 12 786

Knife, Bohemia or Moravia, about 1800. Steel blade, agate and silver filigree. 9969

Shields, Bohemia, 19th century. White brass; silver. 46 120 c; 46 120 e

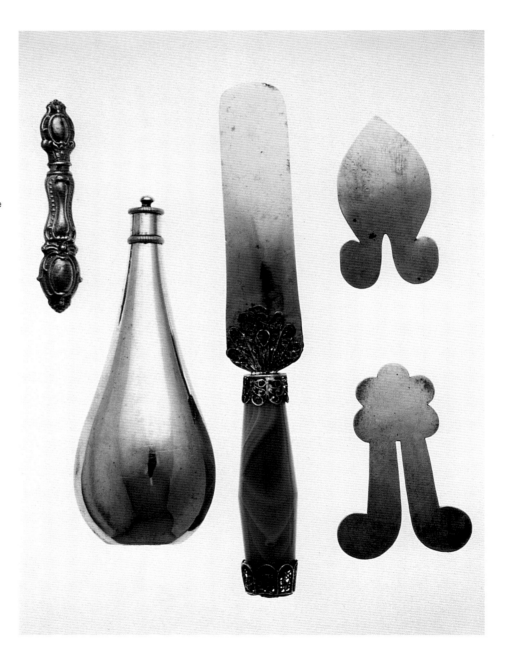

Weddings are central events in many cultures and are marked by several customs and festivities. It is customary for Jewish couples to exchange gifts such as decorative plates and cups in the period close to the wedding day.

Marriage

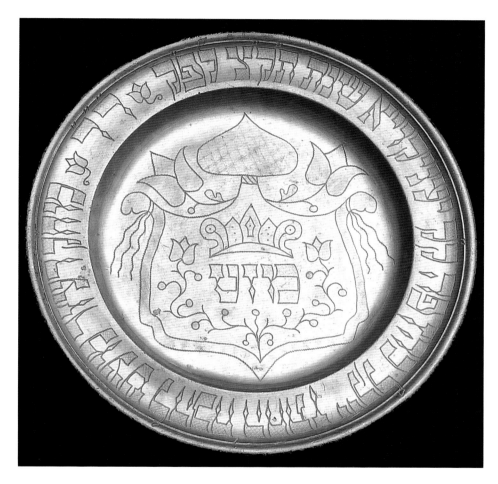

Wedding plate, Bohemia. This hammered and engraved pewter plate was made by Joseph Kunzel of Plzen in 1802. It was presented as a wedding gift to the groom Yikl Cohen in Golcuv, Jeníkov, in 1829–1830. The plate was primarily decorative. 174 491

(right) **Rings, Moravia, 19th century.** *(right)* **According to the inscription, this cast and engraved brass ring belonged to 'Judah son of Rabbi Meinster'. At the centre, the Gemini sign probably refers to the birthday of the owner.** *(left)* **Cast and engraved brass. The engraving reads 'Joseph son of Leib', the sign of Libra points to the birth day.** 4513, 4514

(below) **Rings** *(left)* **Prague or Vienna, late 19th century. Cast and engraved gold with a Star of David adorned with a red stone. The engraving reads '24/5 1891'.** *(right)* **Bohemia, about 1800. Cast and engraved gold. A stylised crown decorates the two Hebrew letters (note: this ring is upside down).** 1021/95, 12 773

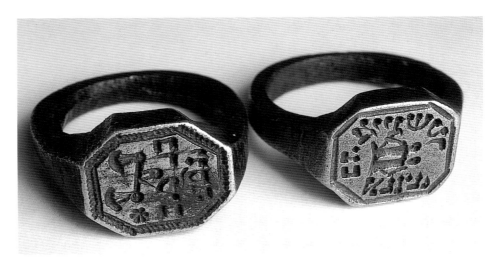

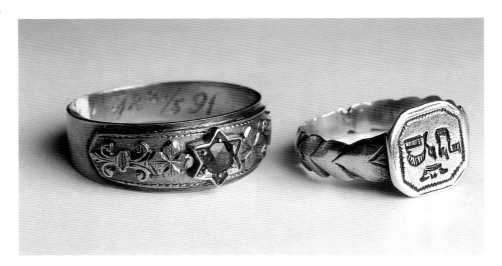

Over 800 items in the Jewish Museum in Prague come from the property of various Bohemian and Moravian burial societies. Members of *Hevrah Kadisha* look after the spiritual needs of the dying and their relatives and assist with arrangements for the burial. After the death they light a candle, hold a vigil and make the necessary preparation for the funeral. Prague's *Hevra Kadisha* was founded in 1564 and was one of the most significant in Europe.

Burial

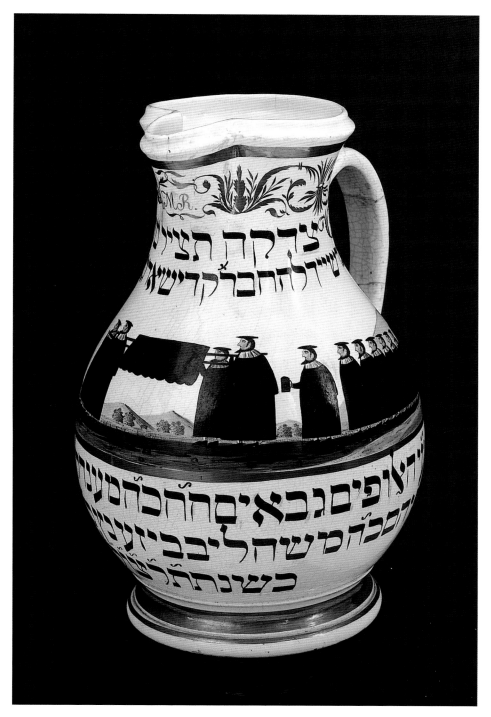

Burial society pitcher, Moravia, 1836. A unique example of a painted and gilt pottery vessel which was used by members of the benevolent society for their annual meetings and special occasions in Mikulov. Some art historians suggest that this pitcher is a copy of an example from the early 18th century. 8048

Six oil paintings on canvas from a series of fifteen depict the activities of the Prague *Hevrah Kadisha* (burial society). The paintings decorated the meeting room where members gathered for their annual banquet. An anonymous artist painted the cycle in about 1780 — an important year for the Jewish community, marking the beginning of the social reforms of Joseph II. Each painting measures 55 x 110 cm.

This page:
(top) Visiting the dying man.

(middle) Taking the body from the house.

(bottom) The oration over the dead man.

Opposite page:
(top) Carrying the body to the grave.

(middle) Lowering the body into the grave.

(bottom) Washing hands leaving the cemetery.

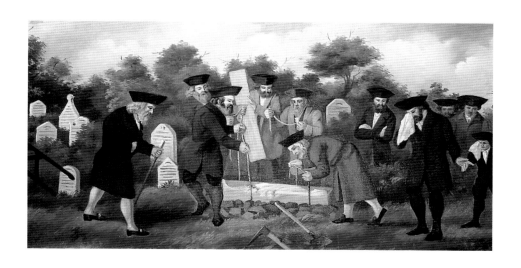

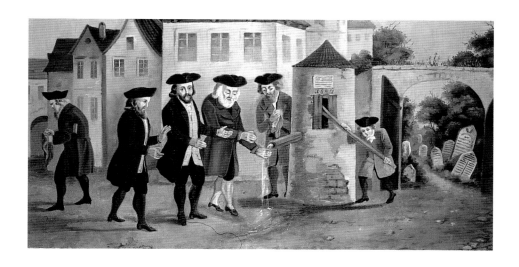

Burial society implements.

From top left clockwise: Double-edged comb from the Prague Burial Society, 1794–1795, cast, cut-out and engraved silver. 49 444

Nail cleaner and case, Moravia, early 19th century. Copper and engraved silver case, engraved and cut-out silver picks. 3793 a,b,c,d

Nail cleaner, Vienna, 1866. Cast and engraved silver. 23 339 a

Comb, Bohemia, 1660 (inscription date). Horn and engraved silver. 173 350

Comb and nail cleaner pick, Moravia, 1742–1743. Engraved, cut-out and silvered copper. 32 328 a,b

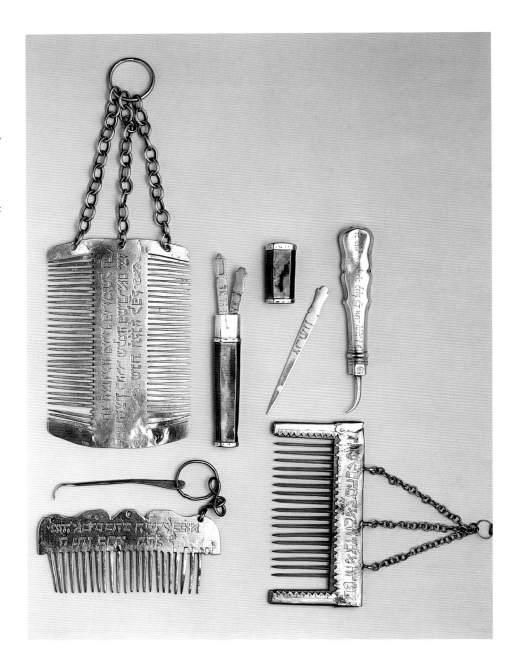

Other

Medal and case, Vienna. In 1860 the Emperor Joseph I granted the Jews of the Austrian Empire the right to own real estate. This cast and engraved silver medal was issued by the Jewish community in Trebíc, Moravia, to commemorate the decree. From then on the Jews of Bohemia and Moravia could freely live and invest outside their ghetto. 61 756

Manuscripts

From the middle ages, illuminated manuscripts were particularly important as a form of artistic expression that did not infringe the second commandment, which prohibits the making of 'a sculptured image, or any likeness of what is in the heavens above or on the earth below, or in the waters under the earth' and adds, 'You shall not bow down to them or serve them …' (Exodus 20: 4–5).

Memorial prayers for the Pinkas Synagogue, Prague, 1822. This manuscript was commissioned by the *Hevrah Kadisha* (burial society) associated with the Pinkas Synagogue. The scribe of this magnificently illuminated manuscript was Simhah Plon.
Ms 74

List of books of Fleisch
Ehrenstamm, Prostejov, 1818.
Manuscript, ink on parchment.
Ms 86

Portraits

The Jewish interpretation of the second commandment has varied according to time and place. Jews in Central Europe sometimes incorporated animal and even human figures into their religious art. In general, painting was preferred to sculpture, which was considered to be closer to idolatry. Nonetheless, there were very few Jewish paintings up to the end of the 18th century. In the 19th century, in line with a general emancipation and assimilation, there was an increase in the production of Jewish portraits, and family portraits were very popular with the middle and upper class.

(opposite page) **Portrait of an older woman in a tulle cap with roses, Prague, about 1850. Oil on canvas. The style of the facial features on this painting, shaped with sculptural definition, was characteristic of Prague portraiture in the first half of the 19th century. Not much is known about this woman. We can only guess from her appearance and jewellery that she belonged to the middle class.** 27 150

These portraits of Karl Andrée, a bookseller in Prague, and his wife Amalie (nee Weiss) may have been painted on the occasion of their marriage. The Andrées exemplify the prosperous Prague Jewish merchant couple of the early 19th century. Vienna (?), about 1835. Oil on canvas. 152 139, 152 140

Portrait of Eleonore Soudeck,
**Prague, about 1855. A hand-
coloured photograph and
watercolour on paper. Prague's
panorama, including the
Charles Bridge and the Prague
castle, can be seen in the
background.** 27 461

Portrait of a scholar, **Prague, 1817. Oil on canvas. Inscribed on one side in Hebrew it reads: 'New Moon of Nissan 5577', and on the other side in German: '18th March 1817'.** 60 715

Yom Kippur, the 25-hour fast of the Day of Atonement, is the most solemn day in the Jewish year. It is the culmination of the period of repentance ushered in by *Rosh Hashanah*. *Rosh Hashanah* is characterised by the repeated sound of the *shofar*, a ram's horn trumpet. During the *Rosh Hashanah* and *Yom Kippur* services, men wear white skullcaps and sometimes a loose white garment (*kittel*) belted with a girdle and buckle.

Yom Kippur

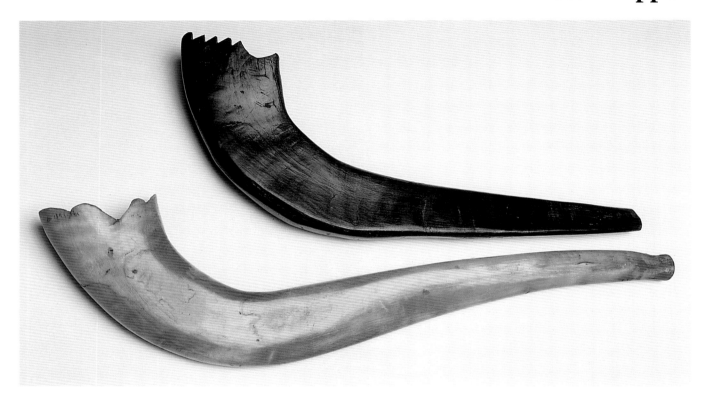

Shofars, **Bohemia or Moravia, 19th century. Carved black horn; carved horn.** 49 432, 869/95

Belt buckle for *Yom Kippur*, probably Eastern Europe, first half of 19th century. Hammered and engraved silver. 6.1 x 10.2 cm. 3992

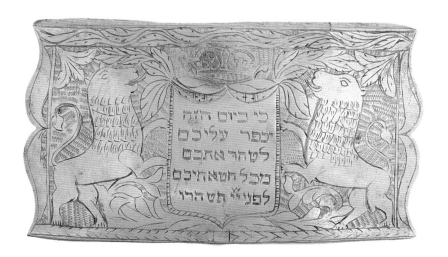

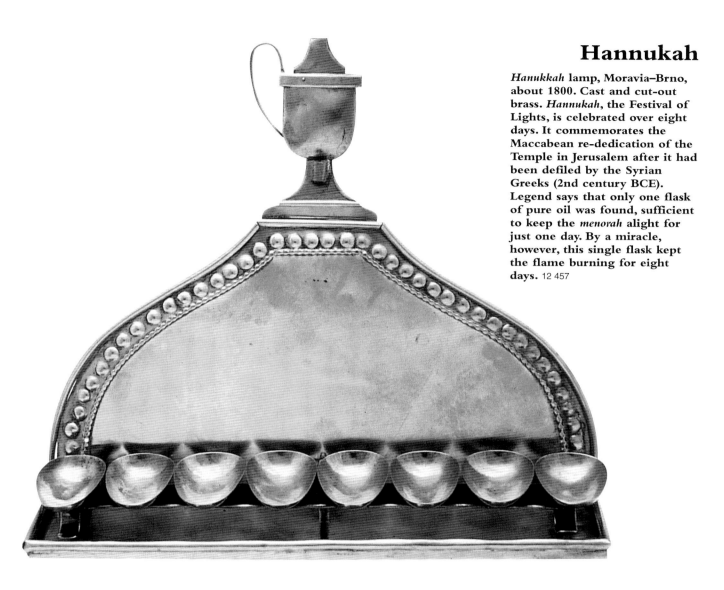

Hannukah

Hanukkah lamp, Moravia–Brno, about 1800. Cast and cut-out brass. *Hannukah*, the Festival of Lights, is celebrated over eight days. It commemorates the Maccabean re-dedication of the Temple in Jerusalem after it had been defiled by the Syrian Greeks (2nd century BCE). Legend says that only one flask of pure oil was found, sufficient to keep the *menorah* alight for just one day. By a miracle, however, this single flask kept the flame burning for eight days. 12 457

Purim

Purim rattle, Bohemia, early 20th century. Carved wood. *Purim*, the Festival of Lots, commemorates the events described in the Book of Esther, when the Persian king, in the 3rd century BCE, wanted to kill all the Jews. Thanks to the courage of the Mordechai and Queen Esther the Jews were saved from genocide. 174 635/3

GLOSSARY

Bar mitzvah (son of the commandment)
A Jewish boy is regarded as an adult from the age of thirteen, when he becomes responsible for his behaviour in the religious sphere. Until then, his parents bear that responsibility. The boy is proclaimed *bar mitzvah* at a ceremony held on the Sabbath after his thirteenth birthday. He is called up to the Torah reading and from then on it is his right and duty to wear a *tallit* and put on *tefillin*.

Bat mitzvah (daughter of the commandment)
A Jewish girl aged twelve is recognised as an adult and is consequently obligated to observe the commandments. The occasion is generally marked by a ceremony. The naming of a girl takes place when the father is called up to the reading of the Torah on the Sabbath after her birth.

Brit milah (covenant of circumcision)
The ritual of circumcision is carried on the eighth day of a Jewish boy's life unless there are medical reasons to postpone it. The circumcision is carried out by the *mohel*, a pious man with the required medical and ritual knowledge.

Decalogue (ten words)
The Ten Commandments were revealed to Moses on Mount Sinai and were engraved on two tablets of stone. A replica of the tablets decorates the Ark in every synagogue to represent the Decalogue's central place in Judaism.

Diaspora
A dispersion of people of common national origin or belief. Originally applied to the Jews scattered among the Gentiles after the Babylonian captivity commencing 586 BCE (Before the Common Era).

Etrog
A citrus fruit native to Israel used on the festival of *Sukkot*.

Hallah
A sweet yellow bread, usually braided, which is served on Sabbaths and holidays.

Hanukkah
See p 101.

Hanukkah lamp
The *Hanukkah* lamp is characterised by a row of eight oil containers or candle-holders shaped like inverted pears; a ninth light, the *shamash* (helper), is used to kindle the others. Oil lamps usually have a backplate, sometimes in the shape of a squarish cartouche or horizontal rectangle decorated by a great range of motifs and shapes. Lamps are usually made of solid silver, copper or brass with or without piercing or applied filigree. The upper section often bears a crown or a floral decoration and the ninth oil container. See also *Hanukkah*.

Hasidism
From the word *hasid* meaning 'pious'. A branch of Orthodox Judaism whose followers maintain a lifestyle based on the teachings of its founder, Israel Baal Shem Tov. *Hasidism* stresses joy, love of man and God, and the need to sublimate evil to good.

Hevrah Kadisha
A voluntary society whose members prepare the dead for burial. The first form of community identification is often the consecration of a plot of land for Jewish burials. Prague's *Hevrah Kadisha* was founded in 1564. After a death in the family, several strict rules are observed. The closest relatives keep a week-long mourning period, known as *shiva*. For eleven months after the death, *Kaddish,* a memorial prayer, is recited. Orthodox Judaism forbids cremation.

Holocaust
The systematic persecution and annihilation of European Jews by the Germany Nazi government and its collaborators between 1933 and 1945. Gypsies, disabled people, homosexuals and others were also targeted.

Jewish calendar
The Jewish calendar, based on both lunar and solar cycles, is regulated by the positions of both the moon and the sun. The start of each new

month is regulated by the new moon, but the solar calendar is maintained by a leap month included seven times in each 19-year cycle. The Jewish New Year begins in September–October. The civil dates of objects listed and described here have been converted from the Hebrew inscriptions. Therefore the dates cover two years for example Jewish year 5533 is 1772–1773; 5446 is 1685–1686.

The Jewish home
The home is an essential partner with the synagogue in Jewish religious observance. Observances include the *mezuzah*; the lighting of two candles to commence the Sabbath and festivals; the erection of the booth for *Sukkot*; the festive meal for *Seder*; and narration of the Exodus story and the lighting of the lamps during *Hanukkah*. The obligations of the individual and family include the dietary regulations (see *Kashrut*).

Judaism
Founded by Abraham about 1900 BCE, Judaism is one of the oldest monotheistic (belief in one God) religions in the world. Orthodox Judaism is a complete way of life, influencing every aspect of the observant's behaviour. There are two main branches of Jewish culture: the Sephardic (Spanish), linked to Babylon and influenced by Arab–Muslim surroundings and the Ashkenazi (Franco–German), the Central European branch.

Kaddish
A prayer of sanctification of God's name, commonly associated with mourning. See also *Hevrah Kadisha*.

Kaporet
A Torah valance, a horizontal textile decoration hung above the Torah Ark curtain (*parochet*) dating from the mid seventeenth century.

Kashrut (being kosher)
Jewish dietary laws requiring meat and poultry to be slaughtered and prepared in a set way; the prohibition of certain animals, birds and fish; the separation of meat and dairy foods; and special laws for Passover.

Kippah (also *yarmulke*)
A skullcap which men wear to cover their heads as a sign of respect to God.

Kohanim (singular *kohen*, also *cohen*, *cohanim*)
Hebrew 'priest'. A descendant of Aaron charged with performing various rites in the Temple. Some well-known Jewish surnames (such as Kohn, Cohen and Katz) generally point to being descended from the Temple priests.

Kosher (fit, proper or correct)
Describes food that is permissible to eat under Jewish dietary laws. Can also describe any ritual object that is suitable for use according to Jewish law. *Kosher* is the opposite of *terefa* or *treife*. (See also *kashrut*.)

Lions
Lions are frequently depicted on Bohemian silver and textile pieces. The Lion of Judah is a symbol of the Jewish people and is also a well-known Czech heraldic symbol.

Maimonides (1135–1204)
Born in Spain, he is regarded as the greatest Jewish philosopher. Maimonides' works had a strong influence in the European centres of Jewish culture for many centuries due to his 'Guide for the Perplexed' and his code of Jewish law.

Matzah
Flat and perforated unleavened bread eaten during Passover. It is made only of flour and water, mixed without any fermentation. (See also Passover.)

Menorah (lamp)
Originally the seven-branched candelabrum of the ancient Temple in Jerusalem. Today, a nine-branched *menorah* is utilised as the *Hanukkah* lamp or *Hanukkiah*.

Mezuzah
On the right doorpost as you walk into a Jewish house is the *mezuzah*: an oblong case containing a small scroll with the first two paragraphs of the

shema (central Jewish prayer) which stresses the belief in the oneness of God. The *mezuzah* is a constant reminder of God.

Mikveh

A ritual bath for spiritual purification used in conversion rituals; by a bride before marriage; and after the period of sexual separation during a woman's menstrual cycle. Some orthodox men immerse themselves in the *mikveh* regularly for general spiritual purification.

Minyan

The quorum of ten adult Jewish men required for public worship.

Mizrach (East)

A decorated wall plaque of religious significance that indicates the direction of Jerusalem.

Sabbath (in Hebrew *Shabbat*)

The rhythm of daily life ceases once a week to celebrate the Sabbath, commemorating the original seventh day on which God rested after completing the creation. On the Sabbath work is forbidden. Food is prepared before the Sabbath begins. The whole house is carefully cleaned and the family ushers in the Sabbath before sunset on Friday with the lighting of two candles by the woman of the house and the recitation of the *Kiddush* (sanctification and blessing over the wine). Sabbath finishes at nightfall on Saturday with a *Havdalah* service (parting with the Sabbath), which separates the sacred from the profane. The *Havdalah* begins with the lighting of a special braided candle. The scent of cloves, kept in spice boxes (*besamim*), gives consolation for the departure of the Sabbath.

Sepher Torah (Scroll of Torah)

See *Torah*.

The synagogue

The synagogue is the centre and the symbol of Jewish religious life. It developed after the destruction of the first temple in 586 BCE, although some scholars date its inception earlier. The focal point is the Holy Ark where the scrolls of the Torah are kept. The reading of the Torah is conducted from a raised desk (*bimah*) traditionally situated in the centre of the synagogue, facing the ark. While the architecture of the traditional synagogue is not prescribed, some points must always be followed such as orientating the building to the east toward Jerusalem and providing separate areas for men and women. The layout of a synagogue has a very basic form, which is often extended by decoration following the architectural style of the period. In traditional synagogues of Central Europe, a large *menorah* stands on the left of the ark while the *shiviti* plaque hangs on the right. The Ten Commandments are attached on the top of the ark, above the curtain and valance.

The Holy Ark is built into the eastern wall of the synagogue (in Australia the Ark is usually north-west) and is often lavishly decorated. The door to the ark is covered with a curtain (*parochet*), made of and adorned with precious materials. The upper valance (*kaporet*) hung above the curtain often matches the decoration of the curtain. High in front of the ark is the *Ner Tamid*, the Everlasting or Eternal Light. 'Ark' in Hebrew is *aron ha-kodesh* (holy chest).

Tallit

A prayer shawl worn by men at morning services with *tzitzit* (fringes knotted in accordance with the biblical prescription in Num 15: 37–41) attached to the corners as a reminder of the commandments.

Tefillin (phylacteries)

Prayer boxes containing four passages from the Torah. For morning weekday prayers men attach them to their heads and arms with black leather straps. In the nineteenth century, beautifully decorated *tefillin* bags were very popular in Bohemia and Moravia.

Temple

The place of worship in ancient Jerusalem, where sacrifices were offered. The first temple was destroyed in 586 BCE and the second in 70 CE (Common Era).

Torah (teaching)

Orthodox Jews believe in the divine revelation of the Torah as handed down to Moses on Mount Sinai. The scrolls of the Torah, which are the most sacred objects in the synagogue, contain the Five Books of Moses (*Pentateuch*). The biblical text is handwritten on the parchment scrolls, which cannot be touched by a bare hand so a pointer (*yad*) is used. On Sabbath and festival mornings there is a reading from the Torah scrolls, which are divided into weekly portions so that the Five Books are read over the course of one year. The whole cycle begins and ends at the autumn festival of *Simhat Torah*. When not in use, the Torah is placed in the Holy Ark and bound by an embroidered or ornate binder (*mappah*), wrapped and adorned with a mantle (*me'il*). A silver shield (*tass*), symbolising the one used by the High Priest in the Temple of Jerusalem, is hung on the front of the mantle. The two wooden rollers of the Torah scrolls represent the trees of life and are decorated with elaborate silver finials (*rimmonim*) or crowns (*keter*).

Wedding ceremony

As in other cultures, the wedding is the greatest day in the life of a Jewish couple. Marriage is based on mutual trust and a pre-wedding agreement, written on a sometimes richly decorated *ketubah*. A wedding cannot take place on the Sabbath or on holy days. Before the wedding, the bride is expected to go to the ritual bath (see *mikveh*). The wedding is generally preceded by the couple fasting from daybreak. The ceremony takes place under the canopy or *chuppah,* the symbol of God's presence and of the new home they will build together. The ring, the blessing of a cup of wine, the breaking of the glass and joyful celebration are all significant parts of the ceremony.

Zionism

The love of Israel and yearning to return there owes its origins to the first Jewish exile in Babylon in 586 BCE. The modern Zionist movement emerged as a reaction to anti-Semitism during the nineteenth century. Its aim for Jewish resettlement culminated in the establishment of the state of Israel in 1948. Judaism is the official religion of the state of Israel.

Festivals

A day on the Jewish calendar begins at sunset. When a date is given for a Jewish festival, the festival or holy day actually begins at sundown on the preceding day. The following are major festivals in the order they appear during the Jewish year.

Rosh Hashana (Jewish New Year)

One of the two holiest days in the year, *Rosh Hashana* marks the anniversary of the creation of the world and the first day of the Ten Days of Repentance, a period of spiritual self-examination that culminates in the other most holy day, *Yom Kippur*. *Rosh Hashana* is characterised by the sounding of the *shofar* (a ram's horn), an ancient musical instrument sometimes decorated with carvings or Hebrew inscriptions. Its sound calls Jews to penitence and prayer. During this festival the Torah mantles, the curtain on the Holy Ark and the cover on the lectern in the synagogue are white, and men often wear white skullcaps. At home, *Rosh Hashana* is celebrated with symbolic ceremonies, such as eating apples dipped in honey and other sweet foods. According to the Jewish calendar, the current year (1998–99) is 5759.

Yom Kippur

The Day of Atonement, marked with prayer and fasting, is the culmination of the period of repentance following *Rosh Hashana*. *Yom Kippur* is the most solemn day of the Jewish religious year when sins are confessed and expiated. The service on the eve of *Yom Kippur* begins with the prayer known as *Kol Nidre*. As a sign of surrender to the will of God some observant Jews wear a *kittel*, a loose white linen garment belted at the waist with a girdle and buckle. The day is marked by fasting and prayer. Work and other activities are forbidden.

Sukkot

The festival of Tabernacles that closely follows *Yom Kippur*. A feature of the celebration is the *sukkah*, a temporary outdoor structure or booth which is covered by palm branches. Its walls may be decorated with textiles or posters. The *sukkah* is a reminder of the wanderings of the Israelites, who spent 40 years in the desert before they could enter the Promised Land.

Pesach (Passover)

A spring festival that commemorates the greatest event in Jewish history, the exodus of the Jews from slavery in Egypt in 1300 BCE. It begins with a *seder* dinner at which the story of the exodus is retold and celebrated. Traditionally, the assembly reads the story from an illustrated Hebrew book called a *Haggadah*. A *seder* or 'order' plate is put in the centre of the dinner table and three *matzot* (unleavened bread) are placed next to it separated by a special cover. Six symbolic foods are placed on the *seder*: a roast bone, recalling the sacrifice of the lamb; a burnt egg, in memory of the festive sacrifice; cress or horseradish, as a reminder of the bitterness of slavery; parsley or potato, symbolising the spring; a sweet mixture of grated apple, nuts and wine representing the mortar used in Egypt to make bricks; and salt and water representing the tears and bitterness of the period. *Matzot* are eaten as a reminder that the people of Israel had to leave Egypt so quickly that there was no time for the prepared dough to rise.

Shavuot (weeks)

Falling seven weeks after Passover, this was originally an agricultural festival marking the wheat harvest. *Shavuot* commemorates the revelation of the Torah at Mount Sinai.

Hanukkah (dedication)

The Festival of Lights marks the liberation of the Jewish people by the Maccabees from the Syrian Greeks about 161 BCE. *Hanukkah* means 'rededication' (of the Temple in Jerusalem) and is celebrated by the lighting of a candle each day in a special candelabrum called a *Hanukkiah*. At home, some families place the candelabrum in a window. A *dreidel*, a top-like toy, is used to play a traditional *Hanukkah* game.

Purim

The Festival of Lots celebrates the time when the Jewish people were saved from destruction in the Persian Empire in the third century BCE. The event is described in the Book of Esther. According to the legend, Haman, the prime ministers of Persia, wanted to kill all Jews and lots were cast for the most suitable date. Thanks to the courage of Queen Esther, the plan was foiled. *Purim* is celebrated with good food, wine and noisy celebrations.

LIST OF OBJECTS IN EXHIBITION

All measurements are given in centimetres.

Height by width by depth, unless otherwise stated.

SYNAGOGUE

Torah

Torah scroll,
Bohemia or Moravia,
1863–1864.
Ink on parchment,
stained wood.
80 x 27 x 16
5369*
(illus p 33)

Textiles

Torah curtain,
Prague, 1685–1686.
Embroidered silk
velvet and silk.
234 x 147
16 703
(illus p 35)

Torah curtain,
Prague, 1686–1687.
Embroidered silk
velvet.
222 x 158
27 360

Torah curtain,
Moravia, 1813–1814.
Embroidered silk.
118 x 105
2900
(illus p 35)

Torah curtain,
Moravia, 1824–1825.
Embroidered silk.
185 x 127
7596
(illus p 39)

Torah curtain,
Bohemia, 1828–1829.
Embroidered silk
velvet.
207 x 1577
175 815

Torah curtain,
Salzburg, 1894–1895.
Embroidered silk.
340 x 202
7228
(illus p 45)

Torah curtain,
Bohemia, 1907–1908.
Embroidered velvet.
239 x 1699
16 512

Torah curtain,
Prague, 1700–1701.
Embroidered velvet.
233 x 137
931 a

Torah curtain,
Mikulov, 1849–1850.
Embroidered velvet.
194 x 130
3420
(illus p 38)

Torah valance,
Prague, 1718–1719.
Embroidered silk
velvet.
76.5 x 193.5
2243
(illus pp 42 & 43)

Torah valance,
Austrian Empire,
1730–1731.
Embroidered silk
velvet.
49 x 153
5166
(illus p 44)

Torah valance,
Bohemia, 19th century.
Linen with metallic
embroidery.
43 x 125
59 890
(illus p 44)

Torah valance,
Austrian Empire,
early 19th century.
Embroidered velvet.
32 x 135
102 010

Torah valance,
Bohemia, 19th century.
Printed silk velvet.
40 x 156
12 027

Torah mantle,
Prague, 1725–1726.
Embroidered silk
velvet.
94 x 51
12 664
(illus p 41)

Torah mantle,
Prague, 1757–1758.
Silk damask with
metallic threads.
84 x 52
65 583

Torah mantle,
Moravia (?), about
19th century.
Embroidered silk
velvet.
54 x 30
2778

Torah mantle,
Bohemia, 1819–1820.
Embroidered silk.
81 x 45.5
52 713
(illus p 37)

Torah mantle,
Bohemia, 1842.
Embroidered linen.
98 x 51.5
5699

Torah mantle,
Moravia, 1867–1868.
Embroidered silk
damask brocade.
81 x 46.5
2783
(illus p 46)

Torah mantle, Bohemia,
late 19th century. Wool
embroidered with silk.
63 x 47
71 211
(illus p 37)

Torah mantle, Bohemia,
19th century. Silk
embroidered with silk.
85 x 45.5
71 006

Torah mantle,
Bohemia, about 1900.
Embroidered silk.
77 x 43.5
40 271

Torah mantle,
Bohemia, 1738–1739.
Silk brocade.
91 x 51
122/74

Torah mantle,
Moravia–Boskovice,
1869–1870.
Embroidered velvet.
86 x 56
2807

Torah mantle,
Moravská Ostrava,
about 1900. Velvet,
gold embroidered.
85 x 46
71 149
(illus p 41)

Torah mantle,
Moravia–Kyjov,
1884–1885. Blue
velvet, gold
embroidered.
83 x 41
32 100
(illus p 40)

Torah mantle,
Moravia–Brno,
1866–1867.
Embroidered dark
red velvet.
81 x 41
7246

Torah binder,
Bohemia–Sušice, 1763.
Embroidered linen.
15 x 300
66 065

Torah binder,
Bohemia–Sušice, 1821.
Embroidered linen.
16 x 296
66 094

Torah Binder,
Moravia, 1857–1858.
Embroidered linen.
9.5 x 213
12 687

Shulkhan cover,
Pinkas Synagogue,
1910. Velvet with
golden embroidery.
118 x 115
40 637

Torah cover,
Moravia–Šaratice, 1819.
Embroidered linen.
66 x 76
119/73

Torah cover,
Bohemia, 1858.
Embroidered linen.
81 x 84
59 893

Torah binder,
Bohemia, 1888–1889.
Needlepoint with silk
on canvas.
22 x 399
56 912

Torah binder,
Frankfurt, 1876.
Painted linen.
20.5 x 357
687/72
(illus p 34)

Torah binder,
Bohemia, 19th century.
Embroidered green
silk.
20 x 286
31 699

Crowns
Torah crown,
Prague, 1839.
Engraved and gilt
silver.
54.5 x 37.5
19/82
(illus cover & p 31)

Torah crown,
Prague, 1872–1882.
Cast and engraved
silver.
29 x 24.5
37 443
(illus p 47)

Torah crown,
Prague, 1913.
Gilt and engraved
silver.
29 x 23
17 561

Finials
Torah finials,
Bohemia, about 1880.
Cut-out end, engraved
silver.
26.5 x 14
2167 a,b
(illus p 49)

Torah finials,
Prague, 18th century.
Repoussé, cut-out
silver.
44 x 18 each
37 571 a,b
(illus p 48)

Torah finials,
Bohemia, 1900.
Cut-out silver.
21 x 10 each
4383 a,b
(illus p 49)

Torah finials,
Vyškov, end of the
19th century. Cast,
cut-out and engraved
silver.
31 x 14
12 239 a,b

Shields
Torah shield,
Brno, 1813.
Repoussé, engraved
silver.
33 x 26.5
37 399

Torah shield,
Vienna, 1813.
Repoussé and
engraved silver.
37 x 28.5
7128
(illus p 51)

Torah shield,
Prague, 1816.
Repoussé and
engraved silver.
22 x 20.4
37 603
(illus p 51)

Torah shield, Prague,
1816. Repoussé and
engraved silver.
31.3 x 30
44 162
(illus p 50)

Torah shield,
Uherské Hradište,
about 1875.
Repoussé and
engraved silver.
34.5 x 25.5
4317

Torah shield,
Prague, 1816.
Repoussé and
engraved silver.
28 x 25
37 616

Torah shield,
Prague, 1831.
Repoussé and
engraved silver.
21.2 x 16.7
174 189
(illus pp 16 & 51)

Torah shield,
Prague, 1816.
Repoussé and
engraved silver.
17.5 x 15.5
104 795

Pointers
(illus pp 52 & 53)
Measurements as length
by diameter

Torah pointer,
Bohemia, 19th century.
Carved and stained
horn.
29.3 x 1.5
1807

Torah pointer,
Bohemia, early 19th
century. Carved wood.
24.5 x 2.2
2147

Torah pointer,
Prague, 1859. Repoussé
and engraved silver.
29.1 x 2.3
4366

Torah pointer,
Moravia, 1902.
Silvered and
engraved brass.
30 x 2.5
4449

Torah pointer,
Bohemia, 19th century.
Cast and gilt silver,
stone.
25.3 x 2.3
10 705

Torah pointer,
Vienna, 1865.
Cast and engraved
silver.
31.7 x 3.3
12 173

Torah pointer,
Prague, 1819.
Cast and repoussé
silver.
26.2 x 2.9
17 489

Torah pointer,
Vienna, about 1850.
Repoussé end
engraved silver.
19.5 x 2.4
17 543

Torah pointer,
Bohemia, early 19th
century. Carved wood.
25 x 2.3
23 130

Torah pointer,
Bohemia, 19th century.
Carved, engraved
wood.
31 x 3
23 503

Torah pointer,
Bohemia, late 19th
century. Carved wood.
32 x 2
32 394

Torah pointer,
Prague, about 1770.
Cast and repoussé
silver.
18.2 x 1.1
32 417

Torah pointer,
Prague, early 19th
century.
Carved wood.
32.4 x 1.7
37 536

Torah pointer,
Prague, early 19th
century.
Carved wood.
26.5 x 4
37 795

Torah pointer,
Bohemia, 1810–1811.
Cast and engraved
silver.
30 x 2.3
48 260

Torah pointer,
Vienna, 1830–1840.
Cast and silver filigreed.
21.3 x 2.8
54 095

Torah pointer,
Bohemia, 1806–1807.
Carved wood.
15.5 x 2.1
101 999

Torah pointer,
Eastern Europe,
early 19th century.
Brass, filigreed,
silvered copper.
34 x 3.7
104 790

Synagogue inventory

Levite set,
Prague, 1818.
Repoussé and
cut-out silver.
Plate: 4.6 x 39 x 24.9,
jug: 30.6 x 16.5
37 707 a,b
(illus p 60)

Levite dish,
Prague, late 19th
century.
Cast pewter, engraved,
hammered.
28.1 diameter
46 133

Levite laver,
Prague, late 19th
century.
Cast pewter, engraved.
19 x 16.8 x 8.6
46 134

Ceremonial beaker,
Augsburg, 1695–1700.
Hammered and
engraved silver.
8 x 6.9
3701

Ceremonial beaker,
Eastern Europe,
about 1850.
Repoussé and
engraved silver.
6.3 x 5.7
174 348
(illus p 60)

Tankard for wine,
Vienna, mid sixteenth
century.
Cast, cut-out and
engraved silver.
28 x 14.5 diameter
2704

Shiviti plaque,
Moravia, 1879–1880.
Silvered, repoussé and
stippled brass.
124.5 x 60.5
1797
(illus p 58)

Shiviti tablet,
Bohemia–Dobríš, 1821.
Papercut, painted.
50 x 43
8089
(illus p 59)

Eternal light,
Prague (?), 1894.
Cast, repoussé and
engraved silver.
27.5 height x 29
diameter. 103.5 overall
height
37 529

Eternal light,
Prague, late 19th
century. Coloured glass,
brass, silver.
85 height x 26
diameter. 90 overall
height
32 916
(illus p 56)

Eternal light,
Prague, late 19th
century.
Repoussé, engraved
and cast silver.
75 overall height x 18
width x 24 height
10 931

Two tablets of
Decalogue, Bohemia,
about 1900.
Cast brass.
75 x 60.4
54 265

Grill for the Bimah,
Prague, about 1775.
Wrought iron.
113 x 89
25/82

Basin for Lavabo,
Moravia, Val. Mezirící,
18th century.
Cast and hammered
copper.
22 x 27 x 35
23 194
(illus p 62)

Synagogal Lavabo,
Bohemia, early 19th
century.
Cast and hammered
copper.
28 x 18 x 18
72 307/1

Alms box,
Bohemia, early 19th
century.
Painted and stained
wood, brass.
48 x 28.5 x 35
66 127
(illus p 54)

Alms box, Bohemia–
Kasejovice, early 19th
century. Carved and
stained wood.
36 x 18 x 15
9720
(illus p 53)

Prayer plaque,
Bohemia, 1722–1723.
Painted brass, wood.
75.2 x 71.9 x 44
13/76

Sconce,
Prague, 18th to 19th
century. Repoussé and
hammered brass.
30.8 diameter x 6 x 15
depth
154 a

Sconce,
Prague, 19th century.
Repoussé and
hammered brass tin.
30.6 diameter. x 47 x
15 depth
10 786/5

Synagogue clock,
Bohemia–Písek, about
1870. Carved and
painted wood.
71 x 46 x 11.55
23 412
(illus p 57)

Hanukkah lamp for the
synagogue, Bohemia,
about 1850. Cut-out
and wrought iron.
108 x 74 x 23
31/96
(illus p 4)

Lectern (stender),
Bohemia, 19th century.
Stained wood.
113.7 x 40.2 x 40.5
173 332

Synagogue key,
Prague, late 19th
century. Cast steel.
24.5 x 7 x 1.3
37 534
(illus p 56)

Alms box,
Bohemia–Hradec
Králové, 1876–1877.
Silver-plated and
engraved cooper.
19.5 height x 13
diameter
1609

Alms box,
Moravia–Brno,
1763–1764. Hammered
and engraved silver.
16 height x 11
diameter
10 355

Alms box,
Vienna, 1819.
Cast and engraved
silver.
16.9 x 8.3 x 13
3797

Torah curtain hook,
Bohemia, 1840–1841.
Painted wood, iron
hook.
25 x 12
54 536/2
(illus p 61)

Torah curtain hook,
Bohemia, 1828–1829.
Painted wood, iron
hook.
25 x 15
54 536/3
(illus p 61)

FAMILY AND COMMUNITY LIFE

Home

Mezuzah,
Bohemia, 19th century.
Carved and stained
wood.
15.4 x 3.2 x 1.5
32 129
(illus p 63)

Mezuzah,
Bohemia or Moravia,
19th century.
Carved and stained
wood.
16 x 3.1 x 2
27 180

Mezuzah,
Bohemia or Moravia,
19th century. Carved
and stained wood.
18.4 x 2.7 x 1.5
66 483
(illus p 63)

Chair,
Bohemia, late 19th
century.
Carved and stained
wood.
97.5 x 40 x 42.2
173 830

Plate,
Bohemia or Moravia,
about 1810.
Cast and engraved
pewter.
33 diameter
37 696
(illus p 67)

Slaughtering knife,
Bohemia, late 19th
century.
Steel blade, walrus
handle.
50.5 x 7 x 2. knife: 41.8
x 3.3 x 2
50 717 a
(illus p 65)

Koshering board,
Prague, late 19th
century.
Carved wood.
37.5 x 56 x 7
91 922 b
(illus p 65)

Form for pastry (fish),
Bohemia, early 20th
century.
Cast iron.
23.5 x 20 x 5
173 600

Form for pastry,
Bohemia, late 19th
century.
Hammered and cast
cooper.
11.5 height x 27.5
diameter
2450

Pastry mould (grapes),
Bohemia, 19th century.
Hammered and cast
copper.
25 x 13.3 x 7.5
173 602

Cream whisk, Bohemia,
19th century. Carved
and stained wood.
33 length
2453
(illus p 64)

Spoon,
Bohemia, 19th century.
Carved wood.
27.8 length
23 806 a
(illus p 64)

Spoon,
Bohemia, 19th century.
Carved wood.
28.6 length
23 806 b
(illus p 64)

Grater,
Bohemia, about 20th
century.
Carved wood, iron.
23 length x 7.2 x 1.5
32 015 a

Grater,
Bohemia, 19th century.
Carved wood, iron.
24.8 length x 8 x 1.7
32 015 b

Supper fork,
Bohemia, 19th century.
Carved wood.
25.7 length
23 805 b
(illus p 64)

Kitchen item,
Bohemia, early 20th
century. Carved wood.
26.3 l x 12
23 749

Roller,
Bohemia, early 20th
century. Carved wood.
42.3 length x 3.8
diameter
23 747 c

Roller,
Bohemia, early 20th
century. Carved wood.
46.3 x 4.3 diameter
23 747 a

Butcher's seal,
Prague, late
19th century.
Engraved seal.
7.3 x 3.5
28/81

Butcher's seal,
Prague, about 1850.
Engraved brass and
carved wood.
5.5 x 1.7
37 472

Matzah cover,
Bohemia, late
19th century.
Embroidered linen.
38 diameter
95 522 K
(illus p 66)

Matzah roller,
Bohemia, early
19th century.
Carved wood, iron.
66.3 x 11
7580
(illus p 66)

Sabbath
Sabbath lamp
(Judenstern),
Bohemia, 19th century.
Cast and engraved
brass.
85–105 height x 29
diameter
32 993

Sabbath cover,
Bohemia, 19th century.
Embroidered linen.
43 x 39
65/73

Hallah cover,
Bohemia, late 19th
century.
Embroidered linen.
40 diameter
65 690

Hallah cover,
Bohemia, 19th century.
Embroidered linen.
38 x 43
17 151 K
(illus p 68)

Pair of candlesticks,
Vienna, about 1890.
Cast end, engraved
silver.
35.7 x 15.5 x 15.5
2700 a,b

Kidush cup for Sabbath,
Bohemia, 19th century.
Painted glass.
8.2 height x 6.5
diameter
95 800 b
(illus p 69)

Spice box,
Central Europe,
about 1800.
Cast and cut-out,
engraved silver.
32.5 x 7.9 x 7.9
174 630

Spice box,
Eastern Europe,
late 19th century.
Cast and engraved
silver.
15.3 x 12 x 12.5
diameter
173 916
(illus p 72)

Spice box,
Central Europe,
about 1900.
Filigree, cut-out silver.
20.8 height x 5.2
diameter
173 725
(illus p 70)

Spice box,
Moravia–Brno, 1856.
Filigree, cut-out silver.
29.3 height x 7.6 x
7.55
12 269
(illus p 71)

Spice box,
Eastern Europe, late
19th century. Cast and
cut-out silver.
13.4 length x 4.5 x 2.8
102 004
(illus p 72)

Havdalah candles,
Bohemia, 20th century.
Braided, coloured wax.
25 x 3.8 x 0.7
2/88
(illus p 73)

Havdalah candlesticks,
Germany, late 19th
century. Cast and
engraved silver.
18.5 x 6 each
12 748

Sabbath plate,
Central Europe,
about 1900. Porcelain,
colour print.
36.8 x 26.2 x 2.5
12 904
(illus p 69)

Tankard for wine,
Bohemia–Ceská Lípa,
1842. Cast and
engraved pewter.
22 height x 18 diameter
27 680

Worship

Skullcap,
Bohemia, 19th century.
Silk velvet.
16 height x 17
diameter
22/73
(illus p 78)

Skullcap,
Bohemia, about 1900.
Embroidered black felt.
7.5 height x 17.5
diameter
61 713

Skullcap,
Bohemia, late
19th century.
Embroidered blue silk
velvet.
8 height x 19 diameter
46 204 A

Skullcap,
Bohemia, 19th century.
Embroidered black
velvet.
7.5 height by 18
diameter
27 053 b
(illus p 78)

Prayer shawl (tallit),
Bohemia, late 18th
century.
Silk damask, silk
brocade.
220 x 140
19 344
(illus p 79)

Prayer shawl (tallit),
Bohemia, 20th century.
Wool and wool fringes.
64 x 184
24 061/d

Prayer shawl bag,
Bohemia, 19th century.
Embroidered velvet.
34 x 36
255/72

Prayer shawl bag,
Austrian Empire, late
19th century.
Embroidered velvet,
cotton threads.
35.5 x 38
241/72

Tefillin bag,
Bohemia, 1893.
Embroidered velvet.
20 x 18
401/72
(illus p 76)

Tefillin bag,
Bohemia, early
20th century.
Crocheted cotton.
20 x 18
339/72

Tefillin bag,
Bohemia, late
19th century.
Crocheted cotton,
silk embroidered.
19 x 14.5
363/72
(illus p 77)

Tefillin container,
Poland, early
19th century.
Silver filigree.
9 x 9
3976
(illus p 73)

Tefillin container,
Poland, early 19th
century. Silver filigree.
9 x 9.2
3956
(illus p 73)

Tefillin, Bohemia, 20th
century. Leather and
parchment.
5.6 x 7 x 8.5
186/94 a
(illus p 74)

Tefillin,
Bohemia, 20th century.
Leather and parchment.
1.9 x 2.4 x 3.1
185/94 b
(illus p 74)

Tefillin,
Bohemia, 20th century.
Leather and parchment.
5.2 x 6.3 x 8.2
23 944/b

Tefillin,
Bohemia, 20th century.
Leather and parchment.
2 x 2.4 x 3.8
17 139

Towel for ritual
handwashing,
Bohemia, about 1900.
Linen damask, linen
fringe.
114 x 60.5
71 439

Mizrah,
Moravia, 1878.
Papercut, painted.
35.5 x 43
50/96

Mizrah,
Prague, 1872.
Velvet embroidered
with pearls.
37 x 34
90/88

Tallith Katan,
Bohemia, 19th century.
White cotton.
19.5 x 55 cm
17 129 A

Circumcision

Circumcision knife,
Bohemia, early 19th
century. Steel blade,
silver filigree.
20.3 x 2
152 211 f

Circumcision shield,
Prague, about 1900.
Silver.
9 x 2.7
46 120 d

Circumcision shield,
Bohemia, late 19th
century. Silver.
9 x 5
12 784 d

Circumcision shield,
Bohemia, 19th century.
Silver.
6.7 x 4.5 x 2.3
46 120 e
(illus p 80)

Circumcision vial,
Prague, about 1850.
Silver.
12 x 4.8
12 786
(illus p 80)

Circumcision vial,
Prague, late 19th
century. White metal.
7.5 x 1.5
61 945
(illus p 80)

Circumcision vial,
Moravia, about 1850.
Engraved silver.
8.6 x 1.5
4502

Marriage

Ring, Moravia, 19th
century. Cast and
engraved brass.
2.7 diameter
4513
(illus p 82)

Ring, Moravia, 19th
century. Cast and
engraved brass.
2.6 diameter
4514
(illus p 82)

Ring, Bohemia, about
1800. Cast and
engraved gold.
2.1 diameter
12 773
(illus p 82)

Ring, Austrian Empire,
late 19th century.
Cast and engraved
gold, red stone.
2.5 diameter
1021/95
(illus p 82)

Bonnet,
Bohemia, early 19th
century.
Embroidered silk.
35 x 25
2588

Wedding apron,
Bohemia, 19th century.
Green silk brocade.
66 x 72
19 343

Wedding plate,
Bohemia–Plzen, 1802.
Engraved pewter.
29 diameter
174 491
(illus p 81)

Burial

Comb for burial
society,
Bohemia, 1660.
Horn and engraved
silver.
12 x 11.7
173 350
(illus p 81)

Comb and nail cleaner,
Moravské Meziříčí,
1742–1743.
Engraved, cut-out
silvered copper.
11 x 15.1.1
32 328 a,b
(illus p 86)

Comb from Prague
Burial Society,
Prague, 1794–1795.
Cast and engraved
silver.
24.2 x 99
49 444
(illus p 86)

Nail cleaner for
burial society,
Vienna, 1866.
Cast and engraved
silver.
11.9 x 2
23 339 a
(illus p 86)

Burial society uniform,
Moravia, early
20th century.
Wool, silk, leather.
120 x 60
48 528

Burial society beaker,
Bohemia–Turnov,
1819–1820.
Painted glass.
13.7 x 12.2.2
57 309

Silverware of the
Prague Burial Society,
Prague, 1821.
Cast and engraved
silver.
12 x 38.4 x 27
46 099

Burial society dishes,
Bohemia–Všeruby,
1838–1839.
Porcelain.
25 diameter
73 048/2,3,4,20,25,26

Burial society dishes,
Bohemia–Všeruby,
1838–1839.
Porcelain.
24.5 diameter
174 790

Soup tureen for a
burial society,
Bohemia, Horní
Slavkov, 1867.
Porcelain.
16 x 31.5 x 24
23 912 B/3

Gravy boat for
a burial society,
Bohemia, H Slavkov,
1867.
Porcelain.
11 x 26.5 x 15
23 905/2

Fish platter for
a burial society,
Bohemia, H Slavkov,
1867. Porcelain.
63 x 24.2 x 4.6
23 912/A2

Other
Medal and case,
Vienna, 1860.
Cast and engraved
silver, velvet. Medal: 7.5
diameter, case: 8.8
diameter
61 756
(illus p 87)

MANUSCRIPTS AND PRINTS

Torat Kohanim and
Mishnat ha-Middot,
1591–1592.
Manuscript,
parchment, ink.
34.5 x 48
Ms 259/1–4

Sefer Tehilim (psalms),
Ivanovice, 1723.
Manuscript,
parchment, ink.
31,7 x 21,5 x 3,5
Ms 90

Prayers for the cantor,
Slavkov, 1734.
Manuscript,
parchment, ink.
38.5 x 28.5 x 2.5
Ms 256

Prayers for the cantor,
Moravia, 1743–1744.
Manuscript, parchment,
ink, binding.
29.5 x 20 x 33
Ms 280

Prayers of the
Pinkas Synagogue,
Prague, 1822.
Manuscript,
parchment, ink.
33 x 23 x 2.3
Ms 74
(illus p 88)

H Englender: Enkat
Bne Temuta,
Prague, 1824.
Manuscript, paper, ink.
18.5 x 12.5 x 1
Ms 353

Scroll of Esther,
Bohemia or Moravia,
early 18th century.
Manuscript, painted
parchment, ink, gold.
17.5 x 206
Ms 417

Scroll of Esther,
18th century.
Parchment, copper-
engraving.
19.8 x 171
Ms 312

Yom Tov Lipman
Heller: Megillat Eva,
1796 (1806).
Manuscript, paper, ink,
14 pages.
23.4 x 19 x 0.7
Ms 156

Scroll of the
Yampls–Segal family,
Prague, 1716.
Manuscript, paper, ink.
35.4 x 1277
Ms 251

Family Scroll of
Simon Meir, Golcuv
Jeníkov, 1817.
Manuscript,
parchment, ink.
23.5 x 53
Ms 253

E Landau: On the
Tractate Berakhot,
Prague, 1783–1784.
Manuscript, paper, ink.
21 x 177
Ms 332

List of Books of
Fleisch Ehrenstamm,
Prostejov, 1818.
Manuscript, parchment,
ink, nine pages.
35 x 15 x 1.2
Ms 86
(illus p 89)

Calendar,
Bohemia, 1783.
Manuscript, paper,
ink, binding.
23.5 x 19 x 1
Ms 116

Register of
Circumcisions of
L Froehlich,
Bohemia, 1805–1853.
Manuscript, paper, ink.
18.5 x 12 x 1.22
Ms 134

Cookbook,
19th century.
Manuscript, paper, ink.
22.5 x 18 x 0.6
Ms 320

Passover Haggadah,
Prague, 1526 (1927).
Print (facsimile), paper,
binding.
24 x 32
II A

I A Hayyut: Sefer
Siah Yizhak,
Prague, 1587.
Print, paper.
19.5 x 15
4235

J L ben Bezalel:
Derush al ha-Torah,
Prague, 1593.
Print, paper, binding.
19 x 15.5
4727

Bundle of Hebrew
printed books,
Prague, 1580, 1595.
Print, paper, semi-
leather binding.
20 x 16.5
12 993

J B Y Ber Miklis:
Sefer Josef daat,
Prague, 1609.
Print, paper, binding.
19 x 15.5
1157

M B A Yaffe: Sefer
Levush ha-tekhelet,
Prague, 1688.
Print, paper, semi-
leather binding.
32 x 21 x 4.5
33 003

S T B J Falakera:
Zori ha-yagon,
Prague, 1612.
Print, paper, cardboard
binding.
17 x 14.5 x 0.7
13 214

J L B O Eilenburg: Sefer Minhat Yehuda, Prague, 1678. Print, paper, leather binding. 29.5 x 38.5
40 639

S B Y Luria: Sefer Yam shel Shelomo, Prague, 1615. Print, paper, semi-leather binding. 29 x 20 x 2.8
2856/a

M Meir Perls: Megillat Sefer, Prague, 1710. Print, paper. 19.4 x 16
3887

Ezekiel Landau: Noda bi-Yehuda, Prague, 1776/7. Print, paper, leather binding. 34.3 x 21.5 x 5
3529

Y B E Landsofer: Sefer Meil Zedaka, Prague, 1756. Print, paper. 20.6 x 35.4
2976/c

Eleazar Fleckeles: Olat Hodesh, Prague, 1785. Print, paper, leather binding. 19.6 x 24
2541 b

Mahzor mi-Reshit ha-Shana, Prague, M I Landau, 1835. Print, paper, cardboard binding. 20.8 x 14
12 432

Sifre Kodesh im Targumim, Prague, M I Landau, 1837. Print, paper. 22.5 x 31
38 006

Talmud Babli. Massekhet Shabbat, Prague, 1830. Print, paper, binding. 44 x 28 x 5.5
2679

Haggada shel Pesah, Prague, 1887. Print, paper. 18.6 x 12.5 x 1
6631

Israelitischer Volkskalender, Prague, 1916–1917. Print, paper. 14.2 x 9.44
12 753/65

Illustrierter Israelitischer Volkskalender, Prague, 1916–1917. Print, paper. 13.5 x 9.88
12 948/65

Kalendár cesko-zidovský, Praha, 1911. Print, paper. 20.2 x 25.5
16/28 a

Kalendár cesko-zidovský, Praha, 1928–1929. Print, paper. 20.7 x 17 x 2.4
16/49

Jüdischer Almanach (Keren Kajemeth), Prague, 1924/25. Print, paper. 18.5 x 23.5
19 c/1

PORTRAITS

Portrait of an older man, Prague, after 1800. Oil on canvas. 82.5 x 45
27 244

Portrait of an older woman, Prague, after 1800. Oil on canvas. 82.5 x 45
27 246

Portrait of a scholar, Prague, 1817. Oil on canvas. 76 x 62
60 715
(illus p 93)

Portrait of a child, Prague, about 1830. Oil on canvas. 48.5 x 42.5
27 262

Portrait of Karl Andrée, Vienna (?), about 1835. Oil on canvas. 76 x 63
152 139
(illus p 91)

Portrait of Amalie Andrée, Vienna (?), about 1835. Oil on canvas. 76 x 63
152 140
(illus p 91)

Portrait of T R Beer, Prague, 1836. Watercolour on paper. 25 x 22.5
152 145

Portrait of Henriette Beer, Prague, about 1836. Watercolour on paper. 23 x 20
152 146

Portrait of an older man, Prague, about 1840. Oil on canvas. 44 x 35
89 245

Older woman in a tulle cap with roses, Prague, about 1850. Oil on canvas. 70 x 57
27 150
(illus p 90)

Portrait of a student, Prague (?), about 1850. Oil on canvas. 52 x 42. Framed: 61 x 51
82 636

Portrait of E Soudeck, Prague, about 1855. Watercolour on paper. 35 x 31
27 461
(illus p 92)

Portrait of S Soudeck, Prague, about 1855. Watercolour on paper. 30 x 24.5
27 462

Portrait of a woman, Prague, about 1870. Oil on canvas. 73 x 60
82 193

Portrait of a young man, Prague, 1889. Oil on canvas. 92 x 58.5
97 152

Portrait of a woman, Prague, about 1820. Oil on canvas. 57 x 45
79 564

Portrait of a young man, Prague, about 1820. Oil on canvas. 57 x 45
79 565

TEREZIN

Transport suitcase of Josef Ernst, Horomerice, 1942–1945. Cardboard, leather. 60 x 38 x 188
174 844
(illus p 21)

Hanukkah lamp, Menorah, Terezín ghetto, 1944. Wood inscribed with ink. 24 x 23.5 x 11
101 871

Seder table, Terezín ghetto, 1944. Wood inscribed with ink, cotton. 16.5 x 32
101 865

Star of David, Terezín ghetto, 1941–1945. Carved wood. 11.5 x 11
174 846

Skullcap, Terezín ghetto, 1945. Felt embroidered with cotton. 10 x 17
174 330

Chain with four pendants, Terezín ghetto, 1942–1945. Brass. 4.2 length
175 907

Pendant SOD 5,
Terezín ghetto,
1942–1945.
Zinc. 4.2 x 4.44
174 332

Badge of Ghetto
Wache Nr 104,
Terezín ghetto,
1942–1945.
Brass. 6.4 x 4.4
174 331

Pendant with
date 7.2.1943,
Terezín ghetto, 1943.
Carved brass.
2.2 x 3.5
176 292

Pendant with coat-of-
arms of Terezín,
Terezín, 1942–1945.
Metal, cotton bow.
7 x 22
132 076

A Aussenberg: Queuing
for Food, Terezín, 1944.
Pen and ink, paper.
32.7 x 24
173 823

A Aussenberg: In the
Terezín caffee,
Terezín, 1944.
Brush and india ink,
paper.
34.5 x 24
174 744

F Bloch: Prayerhouse in
a loft, Terezín, 1942.
Brush and india ink
wash, paper.
22.2 x 30
173 052

F Bloch: Night burial,
Terezín, 1942. Charcoal
drawing, paper.
28 x 33.8
174 777

F M Nágl: Yard of
the house Q 613,
Terezín, 1943.
Oil, brush, paper.
40.3 x 30.8
104 336

F M Nágl:
Three-tired Bunks,
Terezín 1943.
Gouache, paper.
39 x 30.2
157 137

K Fleischmann:
Madhouse in the
ghetto,
Terezín, 1943.
Pen and India ink
wash, paper.
22.3 x 31.2
175 363

K Fleischmann:
Transport to the East,
Terezín, 1943.
Pen and India ink
wash, paper.
22.5 x 33
175 392

K Fleischmann:
Transport from
Germany, Terezín, 1943.
Pen and India ink
wash, paper.
22.5 x 33
175 393

K Fleischmann:
Dispensation of food,
Terezín, 1943.
India ink drawing,
paper.
22.4 x 33
175 611

Lily Bobaschová:
Night, Terezín
1942–1945.
Watercolour, paper.
22 x 300
173 143

Helga Weissová:
In the girls' dormitory,
Terezín, 1944.
Watercolour, paper.
14.9 x 21.9
173 782

Robert Bondy:
Landscape with a tree,
Terezín 1942–1944.
Watercolour, paper.
15.9 x 21.7
174 681

Milena Deimlová:
Memories of home,
Terezín 1942–1945.
Pencil drawing, paper.
34.9 x 244
174 766

Helga Weissová:
In a dormitory,
Terezín 1942–1944.
Watercolour, paper.
15.1 x 22
175 917

FESTIVALS

Rosh Hashana/ Yom Kippur

Yom Kippur Kittle,
Bohemia, about 1900.
Embroidered linen.
180 x 80 x 20
174 555

New Year skullcap,
Moravia, early 20th
century.
White wool.
19.5 height x 18.5
diameter
37 045 B

New Year skullcap,
Bohemia, 19th century.
White silk.
9 height x 18 diameter
42/73

Shofar, Bohemia or
Moravia, 19th century.
Carved black horn.
32.2 x 6 x 3
49 432
(illus p 94)

Shofar, Bohemia or
Moravia, 19th century.
Carved horn.
39.7 length,
6.6 width x 3
869/95
(illus p 94)

Belt buckle for
Yom Kippur,
Eastern Europe, 1816.
Hammered and
repoussé silver.
5.6 x 10.9 x 2
1013/95

Belt buckle for
Yom Kippur,
Eastern Europe, 1816.
Hammered and
repoussé silver.
7.1 x 12.6 x 2
1014/95

Sukkot

Etrog container,
Vienna, 1807–1809.
Cut-out and engraved
silver.
3.9 x 12.7 x 10.22
12 268

Etrog container,
Augsburg, 18th century.
Cut-out, engraved and
gilt silver.
4.4 x 14.1 x 16.6
12 232

Etrog container, Eastern
Europe, 19th century.
Repoussé and engraved
silver.
10.3 x 14.6 x 10.3
37 566

Hanukkah

Hanukkah lamp,
Moravia–Brno,
about 1800.
Cast and cut-out brass.
25.5 x 28.9 x 55
12 457
(illus p 95)

Hanukkah lamp,
Moravia, early
20th century.
Cast and cut-out brass.
31.5 x 30.5 x 19.5
37 680

Hanukkah lamp,
Bohemia, about 1800.
Cast and cut-out brass.
18.8 x 26.5 x 6.6
37 925

Spinning top, Bohemia,
20th century. Cast lead.
2.7 x 1.0
173 818/3,4,5

Spinning top, Bohemia,
20th century. Cast lead.
2.5 x 1.0
1023/95

Spinning top, Bohemia,
20th century. Cast lead.
2.5 x 1.0
1024/95

Purim

Purim rattle,
Bohemia, early 20th
century.
Carved wood.
36.5 length x 24 x 5.5
174 635/3
(illus p 95)

Passover

Matzah cover,
Bohemia, late 19th
century.
Embroidered linen.
140 x 33 open
3408

PHOTO CREDITS

Passover plate, Bohemia, early 20th century. Painted porcelain. 2.5 height x 33 diameter
173 993

Passover plate, Bohemia, early 18th century. Engraved pewter. 3.5 height x 36.3 diameter
37 690

Passover plate, Bohemia, 19th century. Engraved pewter. 4 height x 34.5 diameter
176 480

Passover beaker, Germany (?), late 19th century. Glazed, gilt and cut glass. 9.5 height x 6.9 diameter
173 100

Passover beaker, Bohemia, 19th century. Painted glass. 8.4 height x 6.2 diameter
66 730

Ceremonial beaker, Elias Goblet, Vienna, 1840–1849. Cast and engraved silver. 12.3 height x 9 diameter
17 505

* Jewish Museum Prague object inventory number

JEWISH LIFE IN SYDNEY — FROM PRIVATE COLLECTIONS

Book, Hebrew prayers and instruction, velvet/paper/metal, Prague, 1889. 17 x 12
L3326/1*

Book, Hebrew alphabet, paper, text in Hebrew, Berlin, Germany, 1923. 24 x 17
L3326/2

Book, 'Pessach-Haggadah', paper/cardboard, printed in Hebrew and German, illustrated, Austria, 1929. 30 x 22
L3347/2

Book, 'Moblitby' (Prayers), cloth/paper, text in Hebrew and Czech, Prague, 1937. 19 x 25
L3328/1

Prayer card, 'Jizkor-modlitba', paper, text in Czech and Hebrew, Bratislava, nd. 13 x 7.5
L3328/2

Donation card, paper, text in Czech and Hebrew, nd. 12 x 7.5
L3328/3

Ticket, paper, text in Czech, Jerusalem Synagogue, nd. 9.5 x 14.5
L3328/4

Hanukkah program card, paper, printed in Czech, Czechoslovakia, 1945. 11.5 x 15
L3346/1

Menorah, silver, unknown maker, nd. 20 x 18
L3347/1

Statuette, 'Golem', earthenware, Prague, 1990–1991. 12 x 9
L3326/3

Presentation medal, 90 years foundation of the Jewish Museum in Prague (1906–1996). 5 diameter
L3327/1

Torah scroll, Bohemia, about 1900. 48 x 30
L3346

Torah mantle, Sydney, about 1960. 35 x 30
L3346

Torah scroll, 'Posel Torah', Bohemia, late 19th century. 130 x 54
L3348

Torah mantle, Sydney, about 1960. 106 x 45
L3348

Torah pointer, Sydney, about 1960. 25 x 2.3
L3348

* Powerhouse Museum loan object number

Essays
See photo captions.

Illustration section
Photos by Mark Gulezian courtesy Smithsonian Institution, Washington, and the Jewish Museum in Prague:
Cover & p 31, 33, 35, 36, 41, 42 & 43, 52, 57, 58, 61, 65, 72, 73, 79, 83, 84, 85, 86, 90, 94 *(below)*, 96.

Photos courtesy the Jewish Museum in Prague:
34, 37, 38, 39, 40, 45, 46, 47, 48, 49, 50, 51, 53, 54, 55, 56, 59, 60, 62, 63, 64, 66, 67, 68, 69, 70, 71, 72 *(top)*, 74, 75, 76, 77, 78, 80, 81, 82, 87, 88, 89, 91, 92, 93, 94 *(top)*, 95.

Page 96: Prague rooftops, 1983.

FURTHER READING

Altshuler, D (ed). *The precious legacy: Judaic treasures from the Czechoslovak State Collections*, Summit Books, New York, 1983.

Andgel, Anne. *Fifty years of caring: the history of the Australian Jewish Welfare Society, 1936–1986*, AJWS & AJHS, Sydney, 1988.

Bartrop, Paul. *Australia and the Holocaust, 1933–1945*, Australian Scholarly Publishing, Melbourne, 1994.

Bergerová, N (ed). *Na krizovatce kultur*, Mladá Fronta, Prague, 1992.

Dagan, Avigdor (ed). *The Jews of Czechoslovakia*, volumes I, II, III. Society for the History of Czechoslovak Jews, New York, 1968–1984.

Hammer, Gael. *Pomegranates: a century of Jewish Australian writing*, Millennium Books, Sydney, 1988.

Jewish customs and traditions, Jewish Museum in Prague, Prague, 1994.

Langer, Jiri, *Devet Bran*, Sefer, Prague, 1996.

Levi, J S and Bergman, G F J. *Australian genesis: Jewish convicts and settlers, 1788–1850*, Rigby, Adelaide, 1974.

Medding, Peter. *From assimilation to group survival*, F W Cheshire, Melbourne, 1968.

Price, Charles, 'Jewish Settlers in Australia', *Australian Jewish Historical Society Journal*, volume 5, part 18, 1964.

Rubinstein, Hilary and Rubinstein, W D. *The Jews in Australia: a thematic history*, volumes I and II, William Heinemann Australia, Melbourne, 1991.

Rubinstein, Hilary. *Chosen*, Allen & Unwin, Sydney, 1987.

Rutland, Suzanne D. 'The Jews', in Ian Gillman (ed). *Many faiths, one nation*, William Collins, Sydney, 1988.

Rutland, Suzanne D. *Edge of the diaspora: two centuries of Jewish settlement in Australia*, second edition, Brandl and Schlesinger, Sydney, 1997.

Rutland, Suzanne D. *Pages of history: a century of the Australian Jewish Press*, Australian Jewish Press, Sydney, 1995.

Rybák, C and Parik, A. 'Jewish Prague', *TV Spectrum*, Prague, 1991.

Vytrhlik, Jana, 'On problematic of the influence of Moravian folk art on synagogue relics from Boskovice', unpublished doctoral thesis, Palacký University, Olomouc, Czechoslovakia, 1976.

Zborowski, Mark and Herzog, Elizabeth. *Life is with people: the culture of the Shtetl*, Shocken Books, New York, 1965.

Weinstein, Jay. *A Collectors' guide to Judaica*, Thames & Hudson, London, 1985.

ABOUT THE AUTHORS

Dr Jana Vytrhlik was born in Prague, where she studied Fine Arts; she later completed her doctoral thesis on Judaica. She has worked as an art journalist, book editor and curator in the State Jewish Museum in Prague. After escaping Czechoslovakia in 1981 she eventually migrated to Australia in 1986. Jana Vytrhlik is manager of the Education and Visitor Services Department at the Powerhouse Museum and curated *Precious legacy: treasures of the Jewish Museum in Prague* at the Powerhouse Museum. She is a member of the committee of management for the Sydney Jewish Museum and the Jewish Arts and Culture Council.

Sydney born **Dr Suzanne D Rutland** is an educator, historian and author involved with Australian Jewish history. Her main book, *Edge of the diaspora*, is now in its second edition. Among her many communal involvements she is president of the Australian Jewish Historical Society. She completed her doctorate in Australian Jewish history at the University of Sydney. She was Jewish education coordinator and is now senior lecturer in Jewish Civilisation in Semitic Studies at the University of Sydney.